carscarscarscars carscarscarscars

national geographic *moments*

CARS

by Leah Bendavid-Val

◻ NATIONAL GEOGRAPHIC

Washington, D. C.

This little book combines cars with cameras—two beguiling inventions that developed gradually in the 19th century and revolutionized life in the 20th. ☞ Almost as soon as the automobile hit the road, cultures worldwide imbued it with qualities we would never attribute to other machines or appliances: Surprisingly, our cars could express our identities and aspirations. We may have said we were purchasing a vehicle for its performance and gas mileage, its price and safety features; but

Cars

the truth is that whether we settled upon a Chevy convertible, a Volkswagen bug, a Rolls Royce, a Volvo station wagon, a Corvette, or a Lincoln Continental depended as much on what we wanted to say to the world about ourselves as on practical matters. We could present ourselves as carefree or respectable, distinctive or seductive, humble or bold. We could buy chrome and fins and hood ornaments; we could customize our cars with stripes and flames. ☞ NATIONAL GEOGRAPHIC magazine took up the subject of cars in an enthusiastic 79-page article in October 1923 titled "The Automobile Industry: An American Art that Has Revolutionized Methods in Manufacturing and Transformed Transportation."

The story covered automotive history, technology, and lifestyle and had 76 photographs. You can tell by looking at the pictures that the photographers enjoyed taking them. Cars were the marvelous contraptions of the future, reflecting human ingenuity and holding the key to barely imagined excitement. ✷ It was just over 40 years from the time German engineer Karl Benz designed his three-wheeled automobile—the first gas-driven vehicle not converted from a carriage—to the year that Henry Ford produced the first hugely popular Model T. Cars went from being playthings for the wealthy to everyman's personal ticket to mobility and freedom. The automobile soon became a necessity, even for the unemployed. During the Great Depression of the 1930s impoverished migrants scraped together funds for cars that would take them westward from the Dust Bowl to a hoped-for better life. ✷ The automobile's basic design and the method of its function were devised and implemented in the span of a few years. German engineer Nikolaus Otto invented a lightweight, four-stroke engine in 1876. His internal combustion engine (in which combustion takes place inside the engine and not in an outside furnace) ignited gasoline in a closed cylinder.

The burning gasoline vapor pushed a piston that drove a crankshaft that turned the wheels. Refinements in function and style—pneumatic tires in 1896, the drum brake in 1902, the tilt steering wheel in 1903, the turbocharger in 1911, the self-starter in 1912—were fabricated bit by bit. ❧ Henry Ford contributed assembly-line efficiency, bringing the cost of cars down and making them affordable for nearly everybody. In 1908, when the average worker made less than $500 a year, Ford introduced the Model T for $850 (other similar cars were selling for $2,000 to $3,000). By 1927, the last year the Model T was produced, it sold for $290. ❧ After the Geographic's 1923 magazine story, Society adventurers drove cars where none had gone before, thousands of miles into jungles and across deserts, through Asia and Africa. Each journey resulted in a magazine story. The stories had such titles as "The Conquest of the Sahara by Automobile" (January 1924), "Cairo to Cape Town, Overland: An Adventurous Journey of 135 Days, Made by an American Man and His Wife, Through the Length of the African Continent" (February 1925), and so on. Geographic photographers bravely documented all these journeys. ❧ Hollywood also adored cars from

the early days and loved them year after year. The romantic little convertible in *Two for the Road,* the glamorous hot rod in *California Kid,* the beat-up Ford V-8 that was Bonnie and Clyde's getaway car, the wizardry of the Aston Martin DB-5 in James Bond's *Goldfinger*—these cars took our breath away and enlarged our automotive fantasies. Popular music chimed in with such romantic titles as "In My Merry Oldsmobile," "Six-Cylinder Love," and "Fifteen Kisses on a Gallon of Gas." ❧ Owing to a post-World War II appetite for material ostentatiousness and to the perception that fuel and other resources were unlimited, the 1950s were the heyday of the glitzy-chrome, big-tail-fin look. The economy was booming and everything appeared possible. To keep up with the styles, consumers changed cars every year or two. ❧ This couldn't go on indefinitely. In the 1960s the Vietnam War and a growing awareness that resources were finite led to a degree of restraint. In the 1970s we were sobered by gas lines and shortages, and the result was the sudden popularity of finless, compact cars. A heightened awareness that cars deplete oil resources built over hundreds of millions of years, that they pollute and destroy the landscape, further contributed to the

demise of the long, low-slung gas-guzzler. Pure materialism no longer seemed right. ❧ But it wasn't long before we were filled with nostalgia for the extravagant overstatement of the fifties. A minor fascination with car collecting and restoration that began in the late 1940s gradually grew feverish and has never slowed down. Old cars preserved and lovingly maintained in Cuba happen to be the height of fashion as this book goes to press. Two Geographic photographers, David Alan Harvey and Pablo Corral Vegas, sought them out and photographed them. ❧ For most of the 20th century the mechanics of cars were easy to understand, at least for young American males, who spent hours under the hood changing belts and hoses and tuning up engines. Nowadays all that has changed: Computers monitor every aspect of performance. No longer can most automobile owners look into their engines and know what's what. ❧ NATIONAL GEOGRAPHIC magazine devoted an entire story to the automobile only once since that long article of 1923. It was titled "Swing Low, Sweet Chariot: The Automobile and the American Way." It was published in July 1983 and in familiar Geographic style it covered the topic from every angle—design and safety, classic-car

collecting, statistics on foreign imports—and it told the stories of car luminaries from Karl Benz to Lee Iacocca. An occasional shorter story, a piece on stock car racing in June 1998, for example, kept Geographic readers abreast of selected aspects of the industry. ❧ National Geographic's primary mission did not directly include documenting the history of the automobile. And Geographic photographers were not automotive professionals who specialized in taking pictures for car magazines and manufacturers. Yet over the years they photographed something both more and less: In simply responding to people and situations that touched them, they recorded telling moments involving people and their cars. ❧

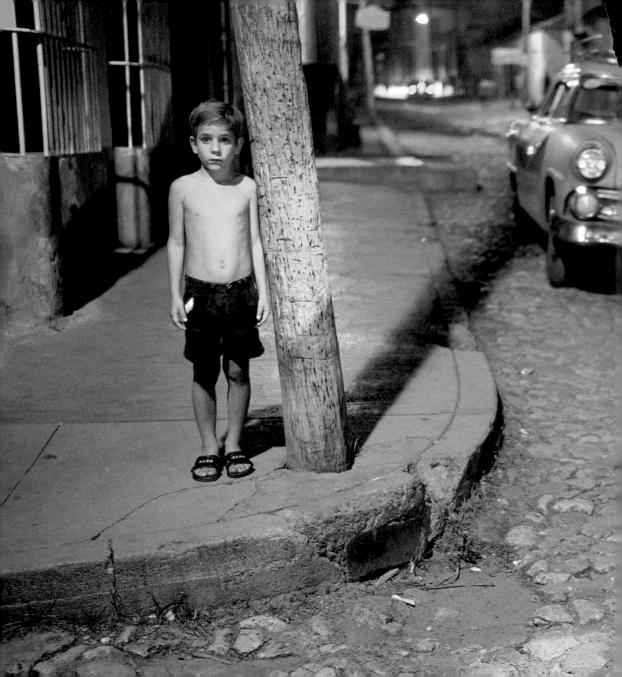

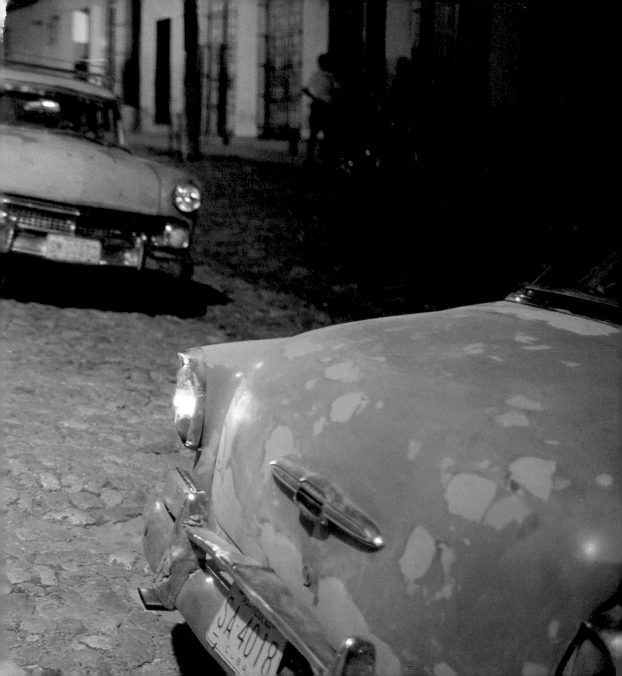

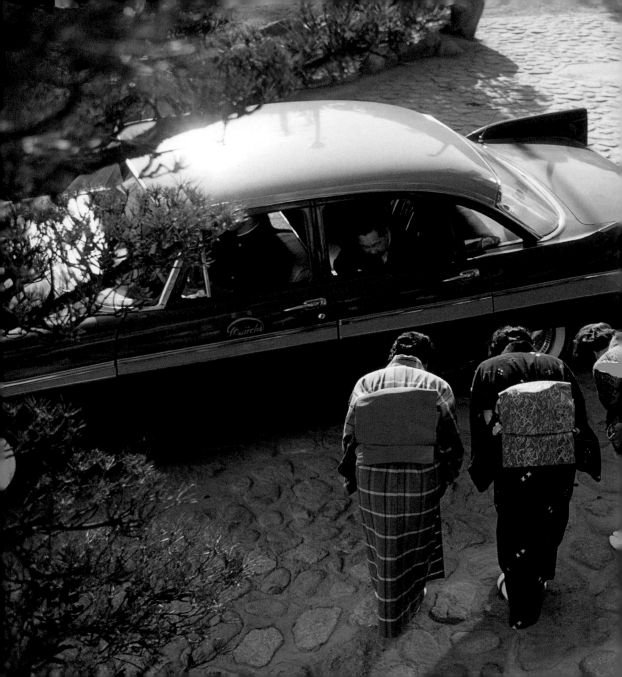

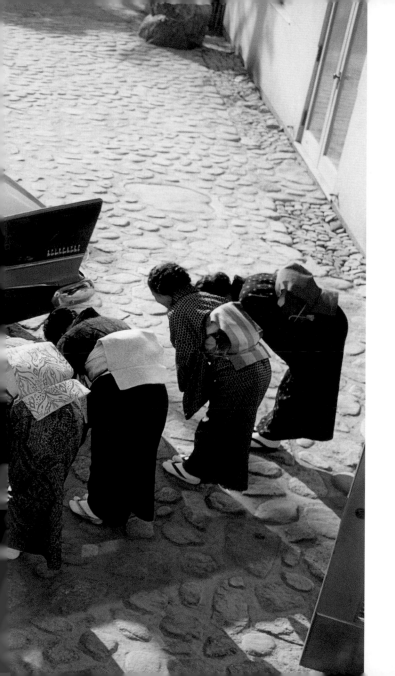

MATSUYAMA, JAPAN
1960
JOHN LAUNOIS

preceding pages
TRINIDAD, CUBA
1999
DAVID ALAN HARVEY

following pages
PITTSBURGH, PENNSYLVANIA
1991
NATHAN BENN

VENTURA, CALIFORNIA
1980
BRUCE DALE

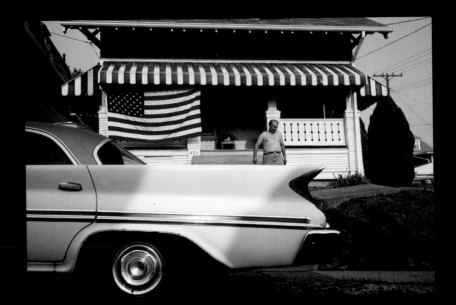

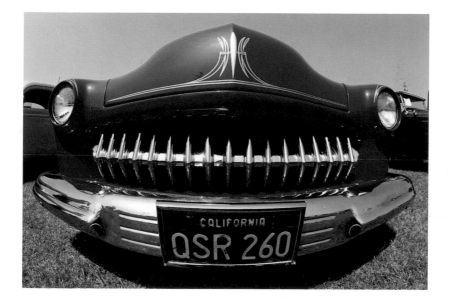

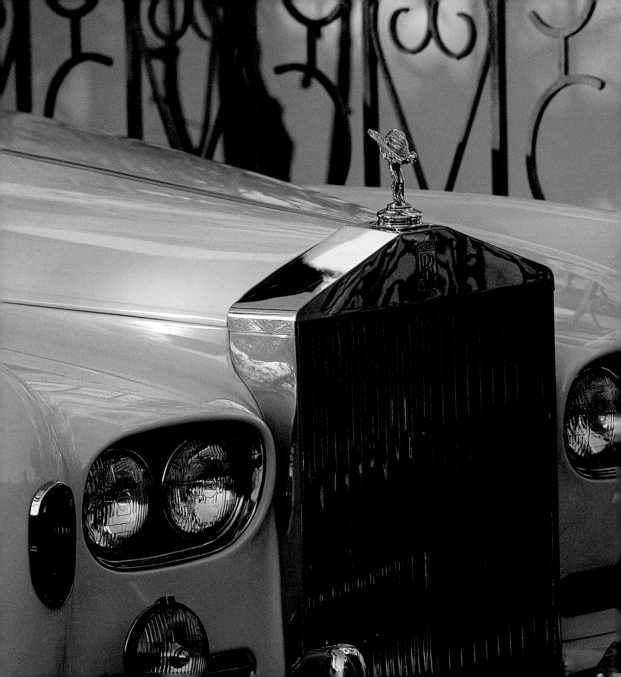

VICTORIA PEAK, HONG KONG
1991
JODI COBB

preceding pages
LAS VEGAS, NEVADA
2000
TOMASZ TOMASZEWSKI

SAN JOSE, CALIFORNIA
1980
STEPHANIE MAZE

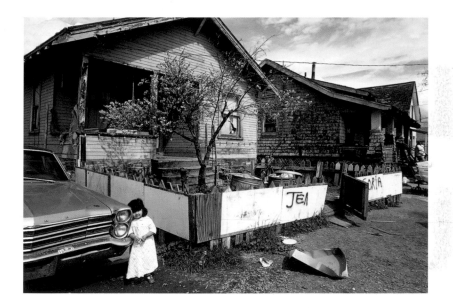

National Geographic photograph

ers and editors marveled at the ingenuity of the assembly line, still a relatively new concept in 1923. In October of that year a magazine caption pointed out that "when cars were first built, all the parts were simply dumped in piles on the floor. Now a frame starts down one line, an engine block down another, a transmission and rear axle down others. When they all meet, they...are ready to be united into a completed chassis on the final assembly line."

GERMANY
1948
WORLD WIDE PHOTOS

following pages
NEVADA
1953
UNITED PRESS PHOTO

TURIN, ITALY
2002
WILLIAM ALBERT ALLARD

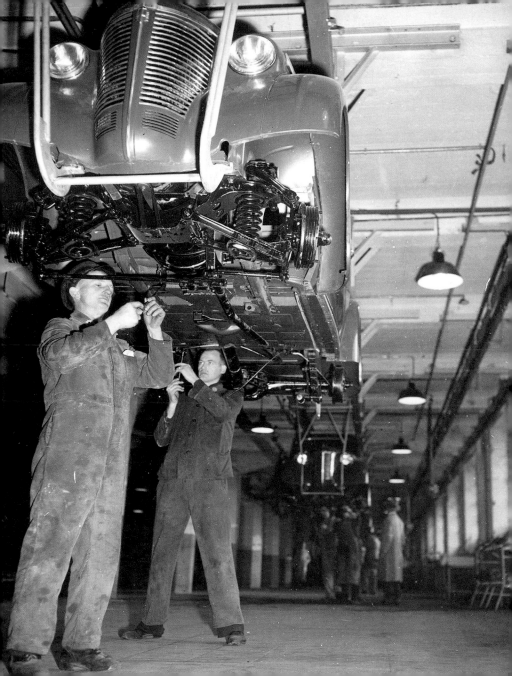

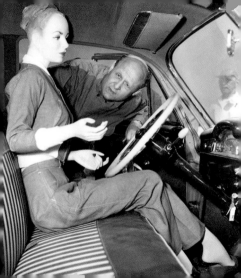

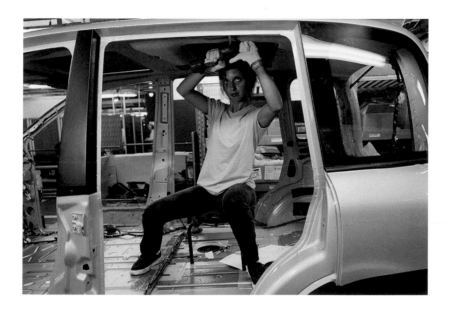

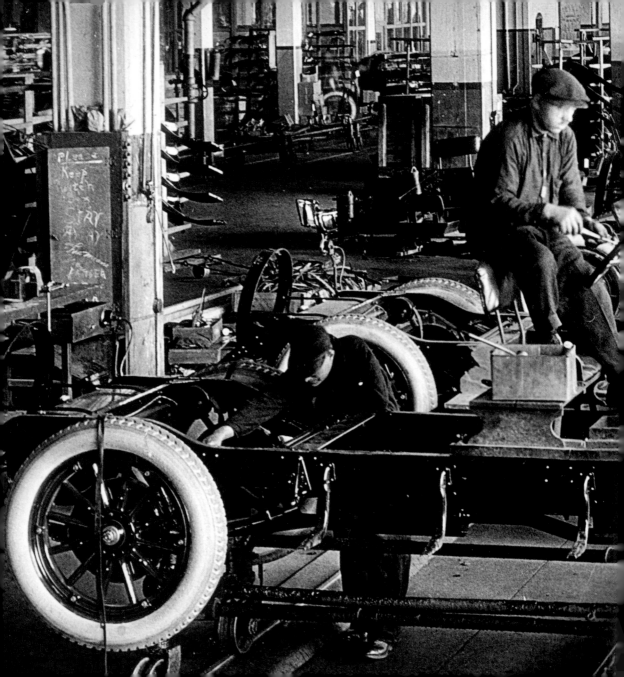

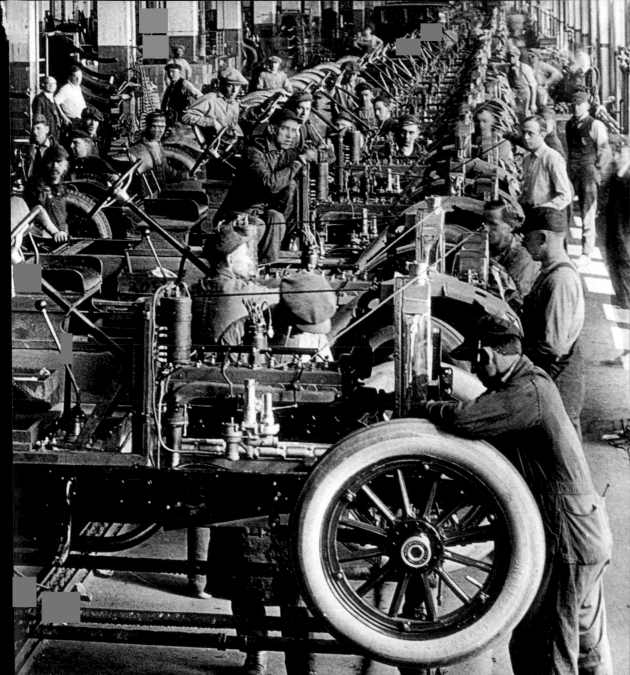

IDAHO
1944
MAYNARD OWEN
WILLIAMS

preceding pages
USA
1923
PACKARD MOTOR CAR
COMPANY

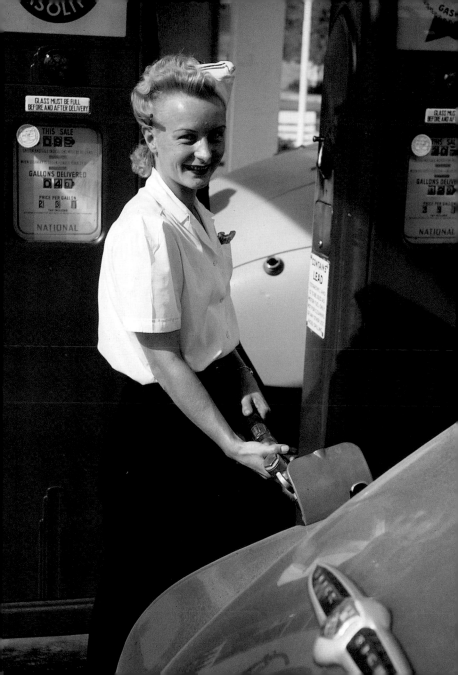

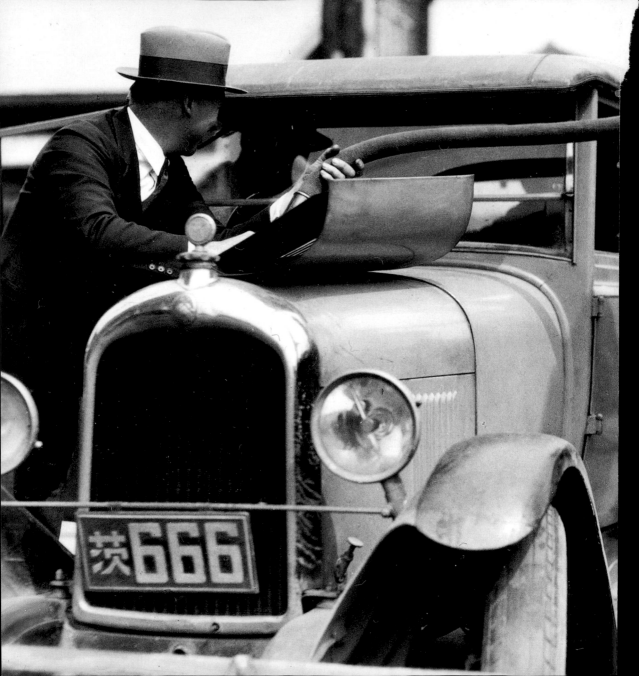

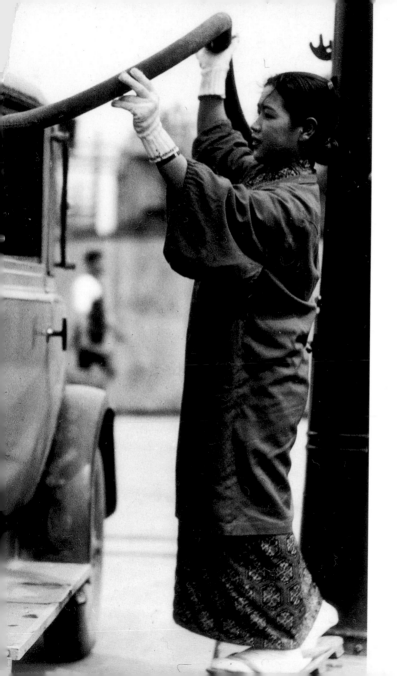

JAPAN
1942
WILLARD PRICE

USA
1904
SMITHSONIAN INSTITUTION
NATIONAL MUSEUM
OF AMERICAN HISTORY

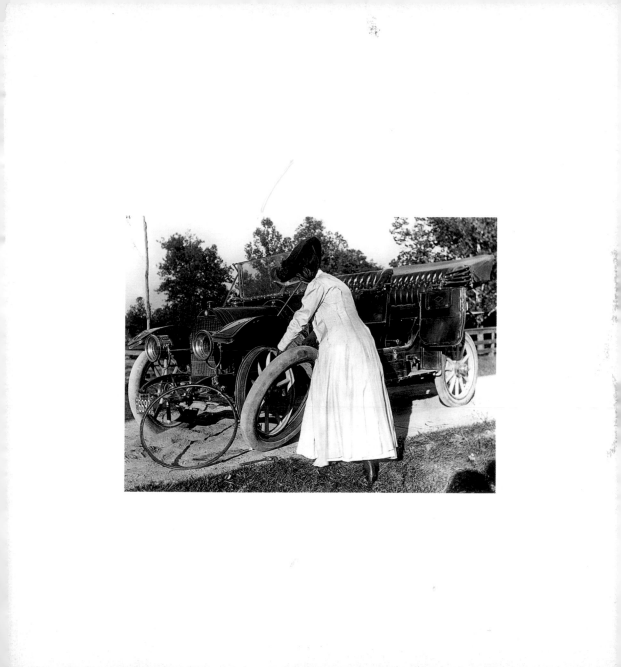

TRINIDAD, CUBA
1999
DAVID ALAN HARVEY

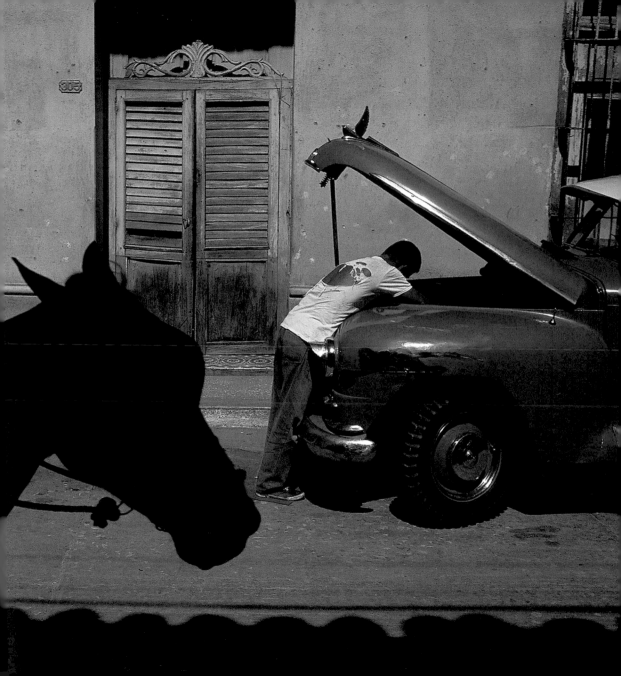

GREAT SANDY DESERT,
AUSTRALIA
1989
SAM ABELL

following pages
COLORADO
1922
DENVER TOURIST
& PUBLICITY BUREAU

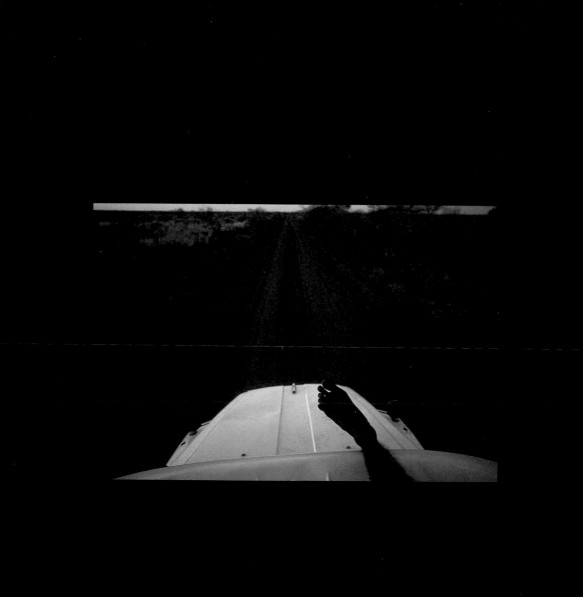

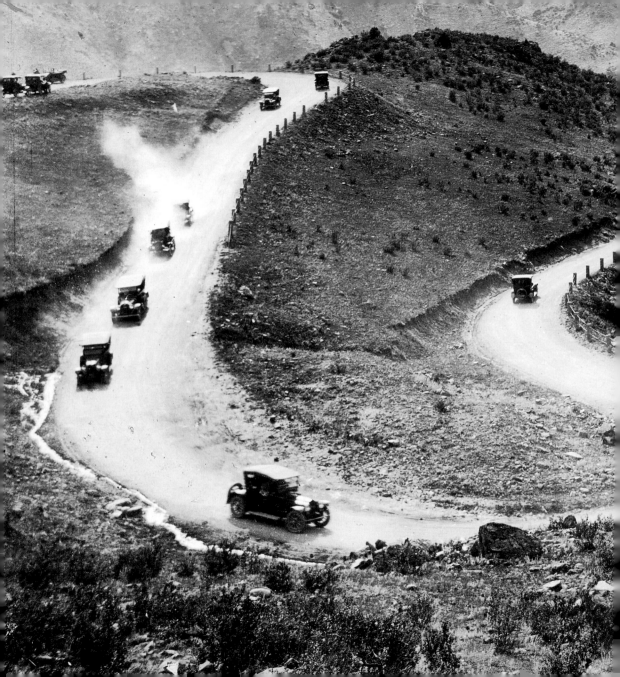

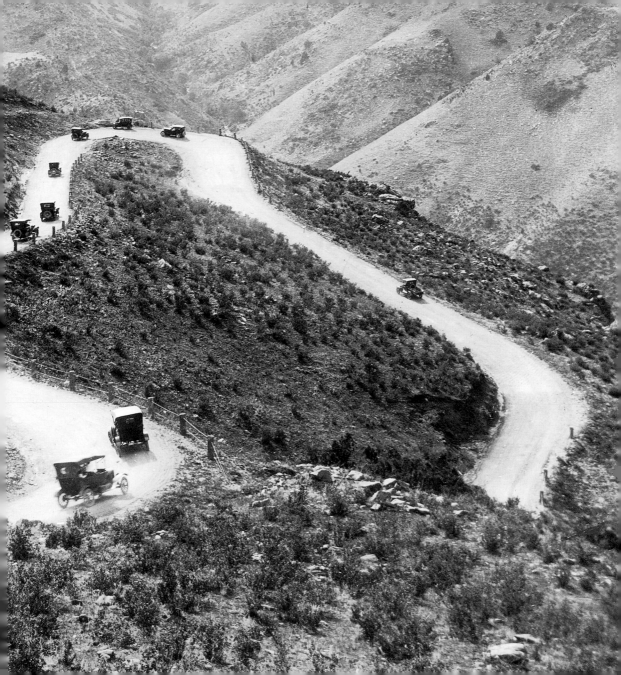

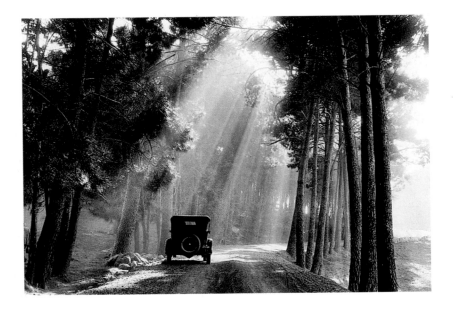

SOUTH AFRICA
1931
BRANSON DE COU

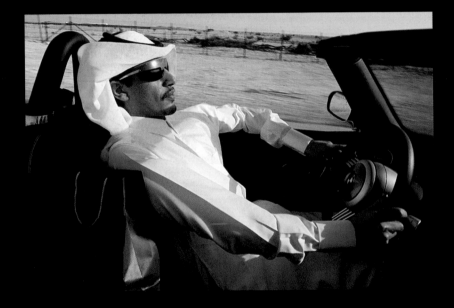

QATAR
2003
ROBB KENDRICK

following pages
NEPAL
1950
VOLKMAR WENTZEL

GUNTERSVILLE DAM LOCK,
KENTUCKY
1948
J. BAYLOR ROBERTS

MADRID, SPAIN
1931
BURTON HOLMES

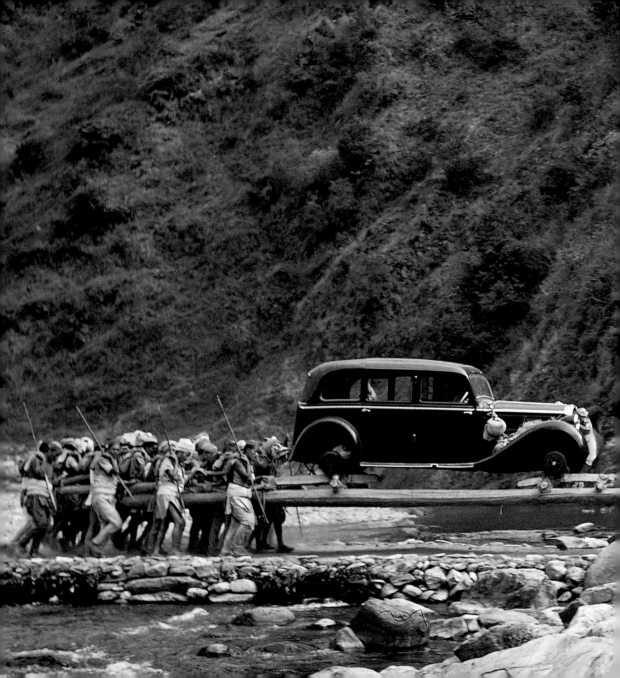

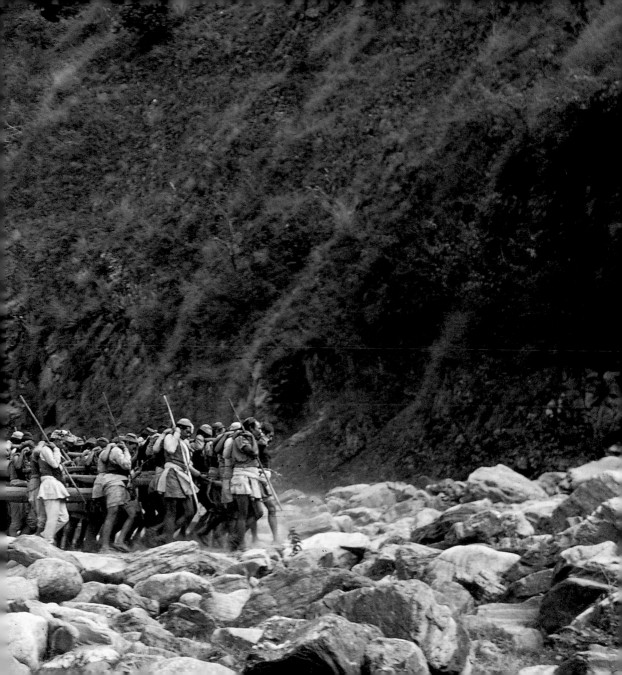

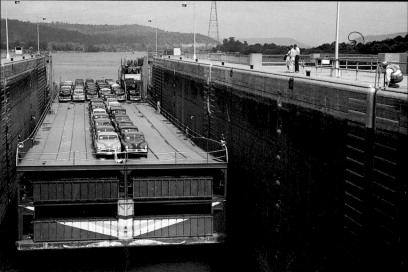

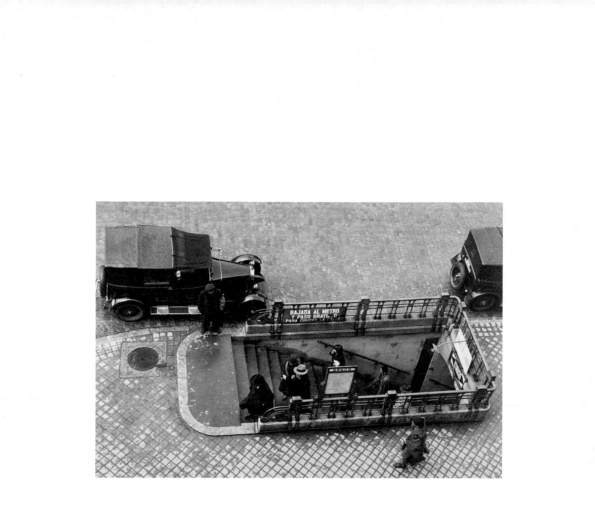

From Prague to Naples to Havana,

London, and New York, automobiles and street life are inseparable. Photographers, also in the street, watch the jumble of vehicles and teeming humanity. They record cars serving commerce and social needs, and simply giving texture to daily life. In the 20th century the automobile turned the world upside down, and increasingly sophisticated cameras documented telling moments.

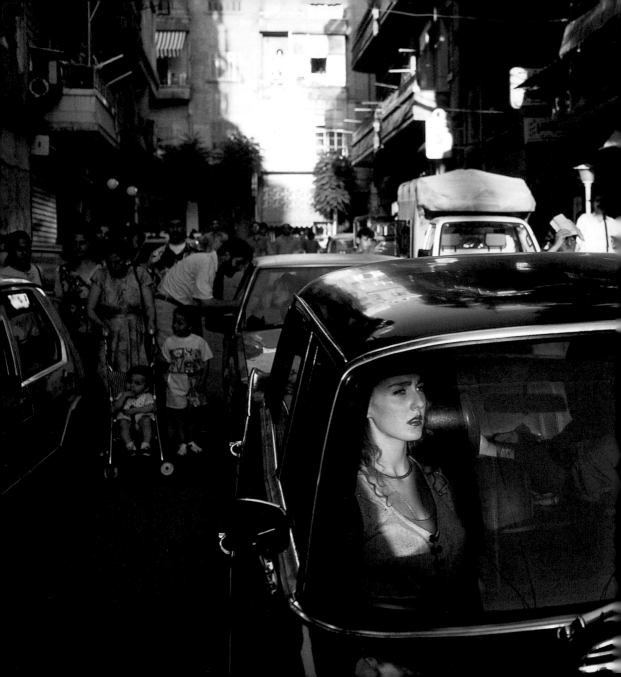

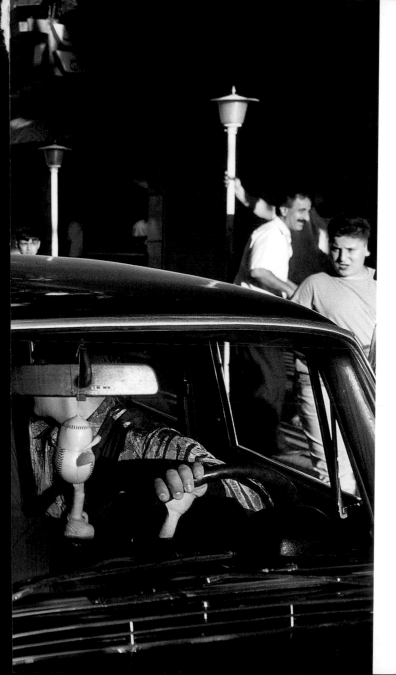

ALEPPO, SYRIA
1996
ED KASHI

following pages
MINNESOTA
1932
CLIFTON ADAMS

LONDON, ENGLAND
1937
KEYSTONE VIEW
COMPANY

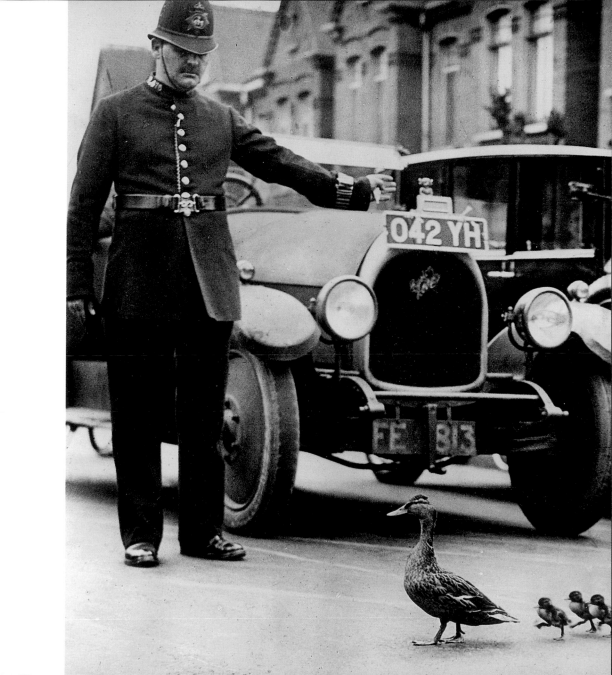

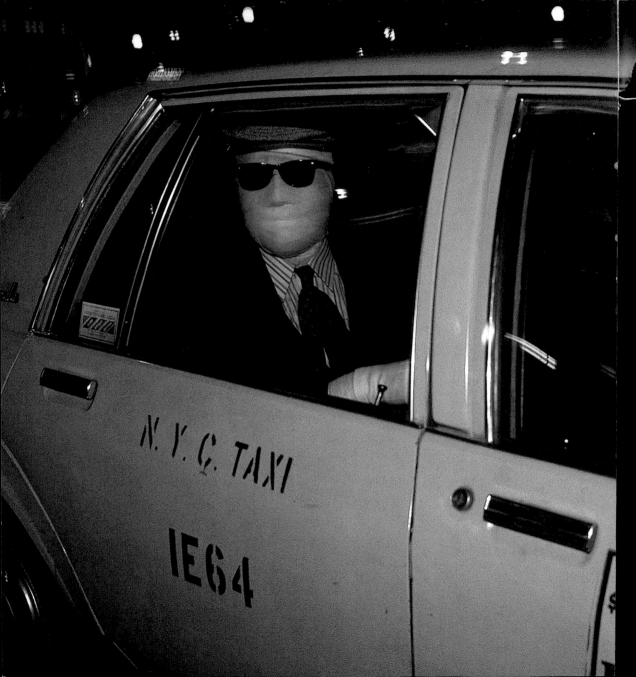

NEW YORK CITY, NEW YORK
1990
JODI COBB

following pages
NAPLES, ITALY
1998
DAVID ALAN HARVEY

PITTSBURGH, PENNSYLVANIA
1978
CARY S. WOLINSKY

PRAGUE, CZECHOSLOVAKIA
1993
JAMES L. STANFIELD

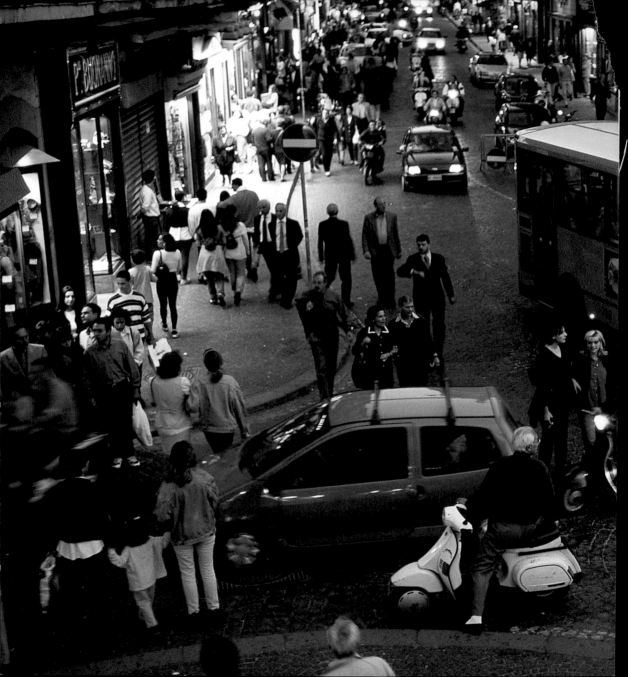

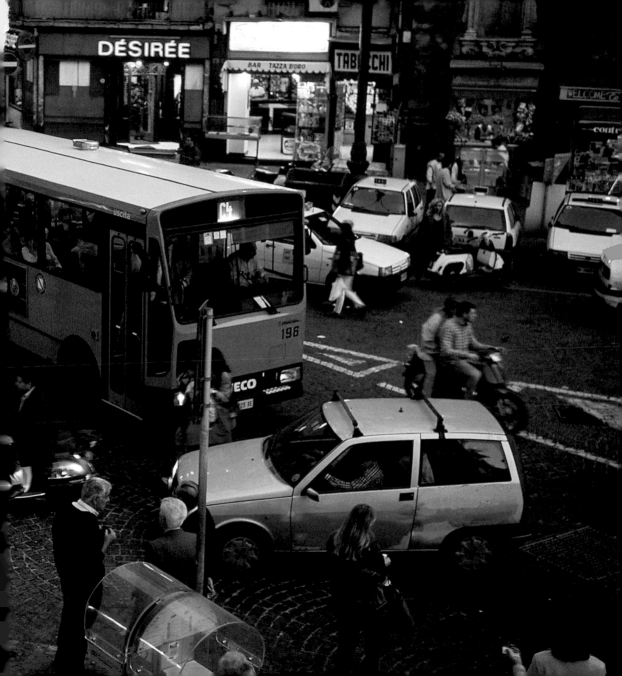

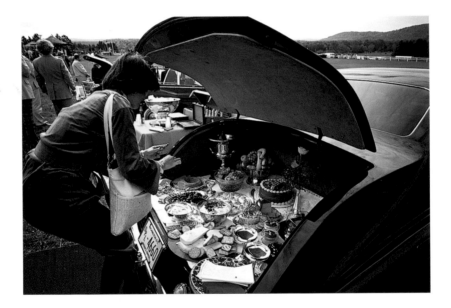

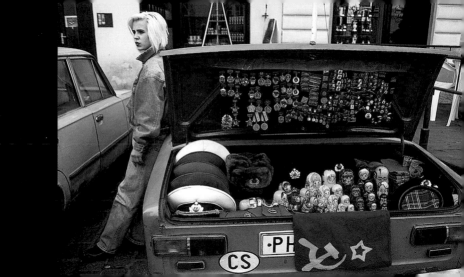

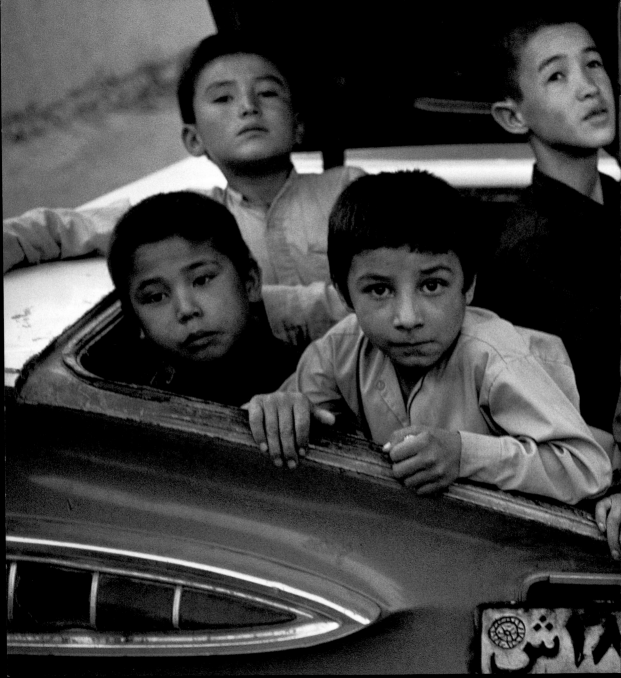

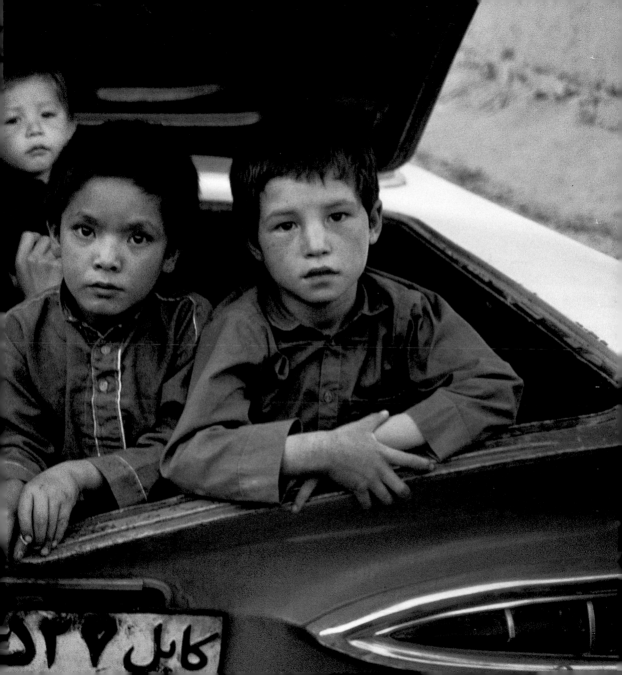

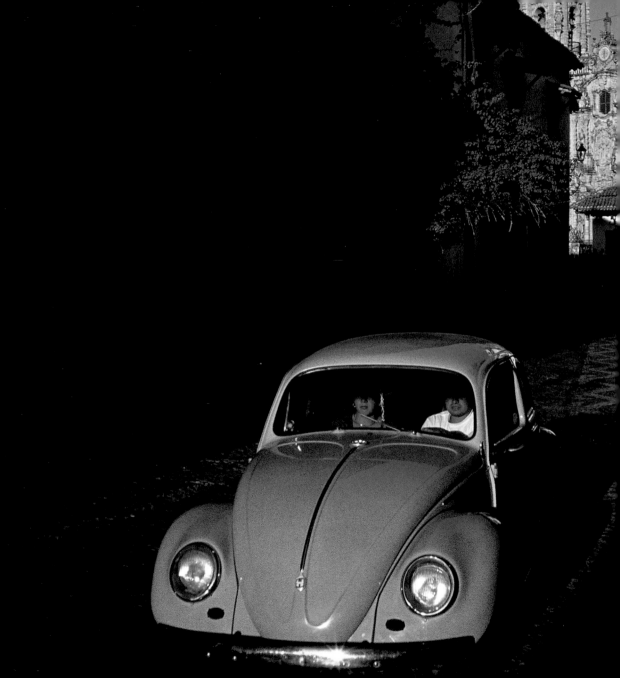

MEXICO
1996
DAVID ALAN HARVEY

preceding pages
KABUL, AFGHANISTAN
1993
STEVE MCCURRY

following pages
HAVANA, CUBA
1999
DAVID ALAN HARVEY

LOCK HAVEN, PENNSYLVANIA
1993
BILL LUSTER

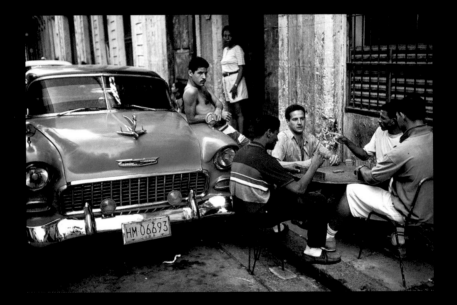

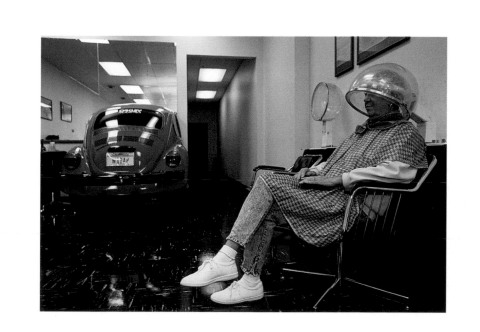

HAVANA, CUBA
1999
DAVID ALAN HARVEY

following pages
THERA, GREECE
1979
SAM ABELL

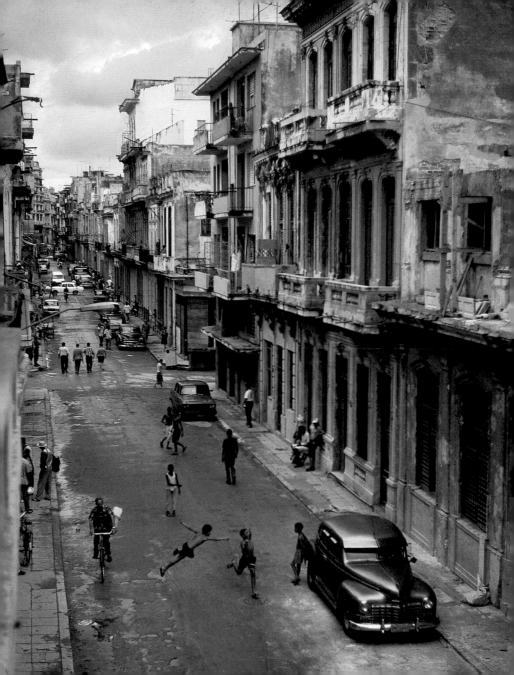

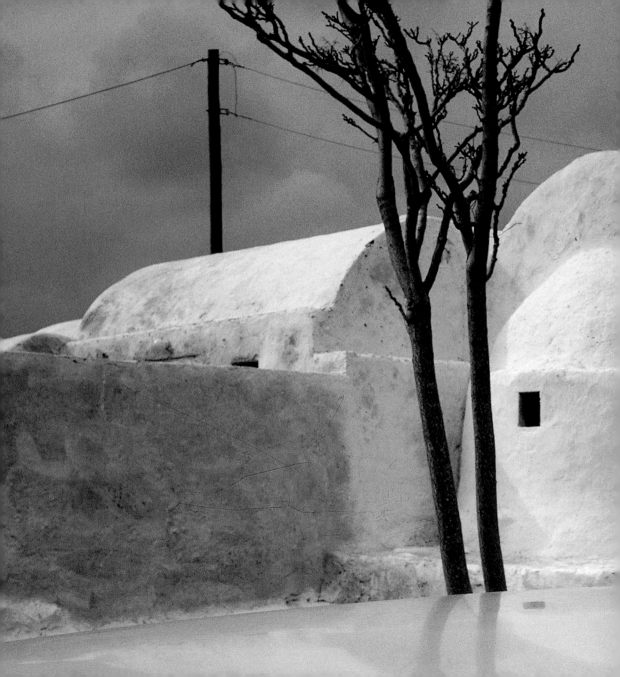

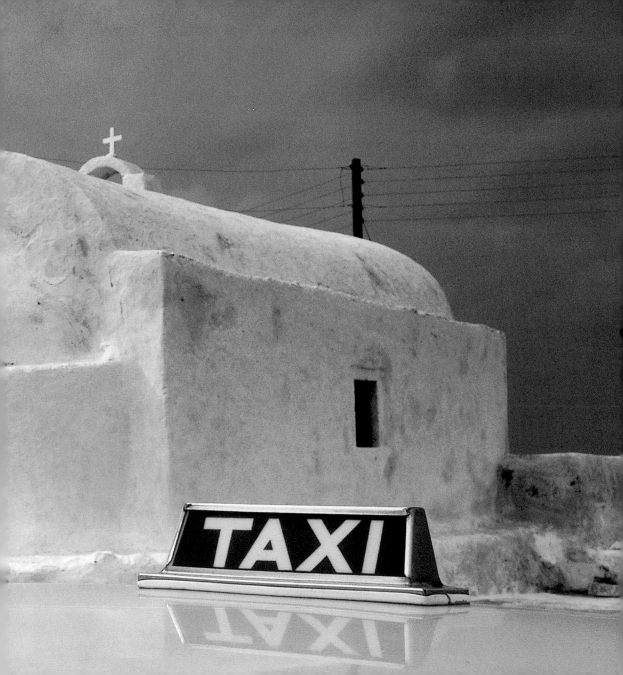

A driver's bad luck can be a wind

fall for small businesses in nearby neighborhoods.

In the 1930s Tunisian Berbers earned money by pushing foreigners'
cars out of sand dunes; in the 1960s a reliable horse and cart served
accident victims in Genoa, and when cars rolled into Amsterdam canals
firemen usually showed up. Auto accidents may also bring good for-
tune to passing photographers: Pictures of wrecks proved popular with
readers of early newspapers and magazines, and they still do.

TUNISIA
1937
MAYNARD OWEN WILLIAMS

following pages
MEXICO
1938
JAMES AND FLORENCE
MCCLURE

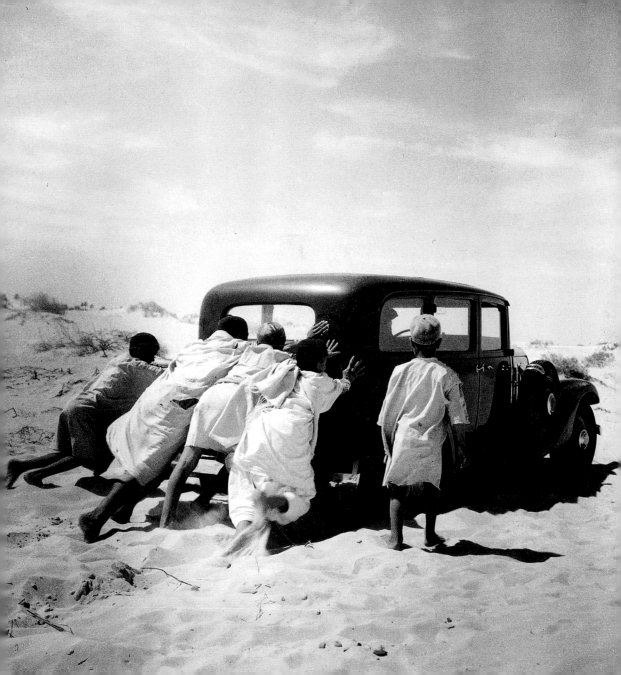

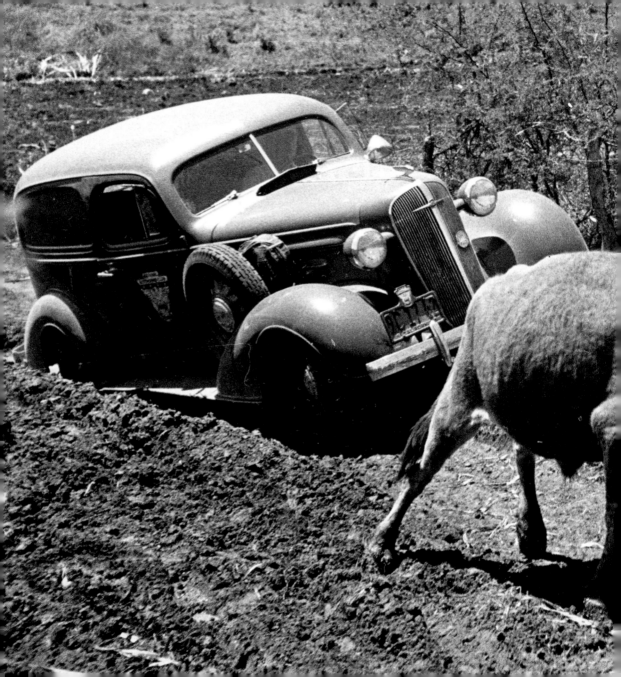

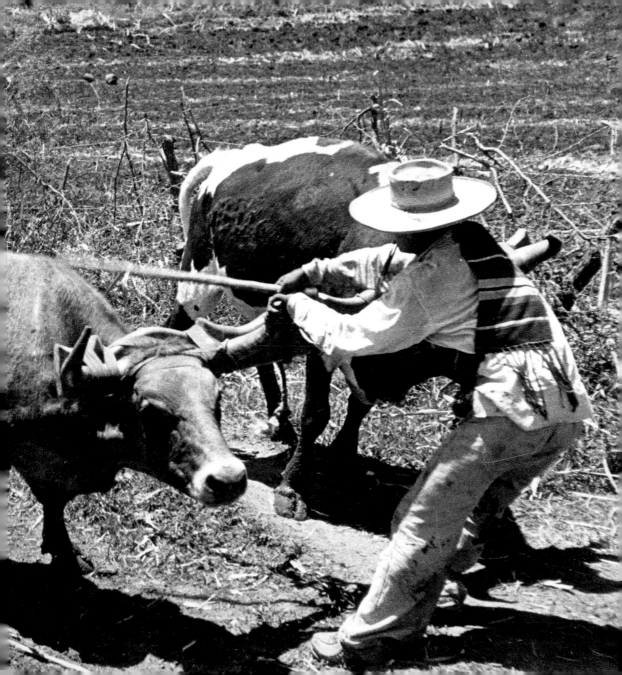

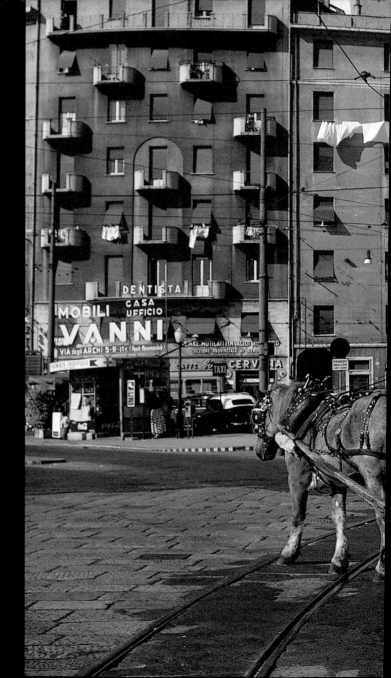

GENOA, ITALY
1963
ALBERT MOLDVAY

following pages
LOUISIANA
1992
JOEL SARTORE

WESTERN AUSTRALIA
1989
SAM ABELL

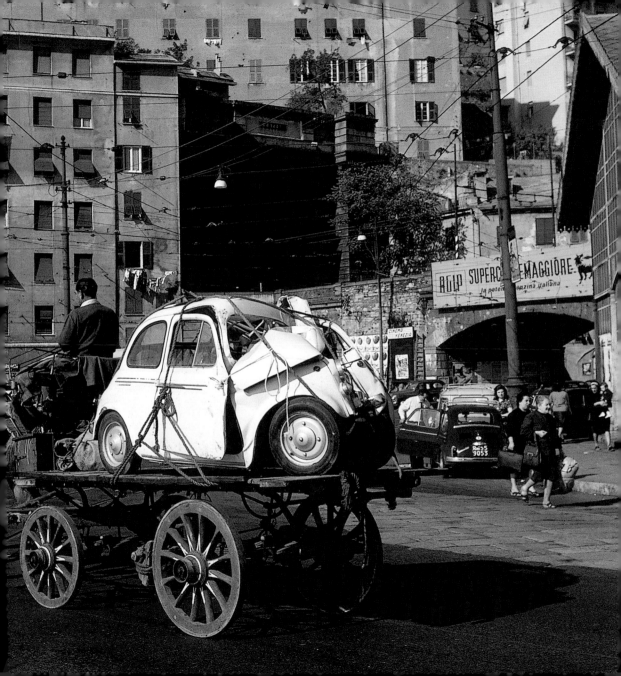

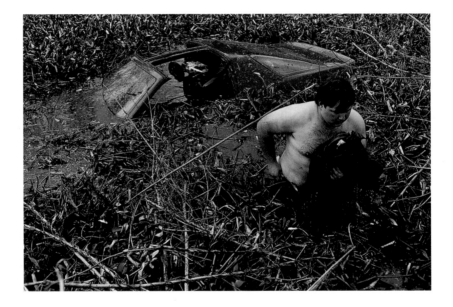

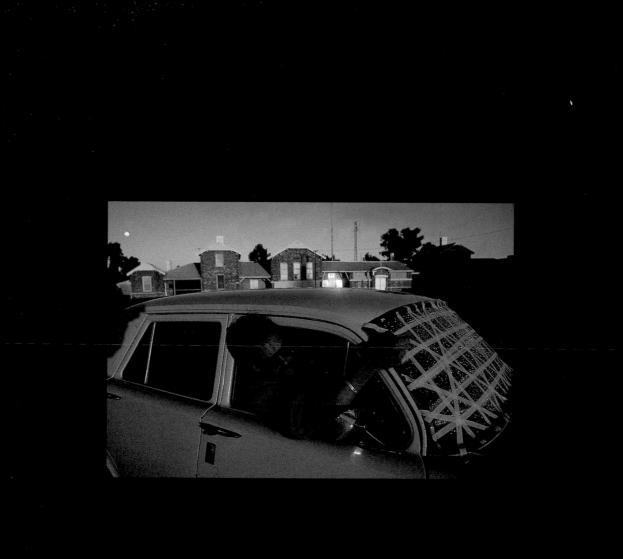

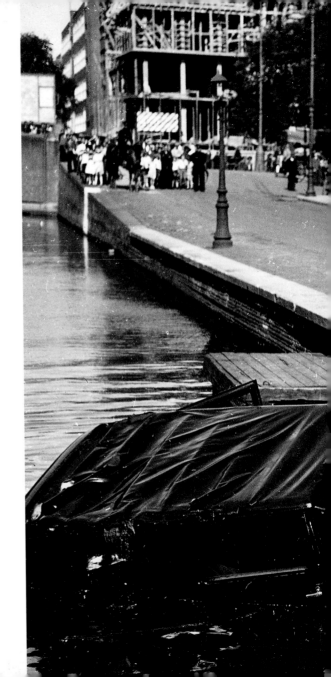

THE NETHERLANDS
1938
MCFALL KERBY

following pages
WASHINGTON, D.C.
1947
B. ANTHONY STEWART

BELGIUM
1940
C. ANDERS & COMPANY

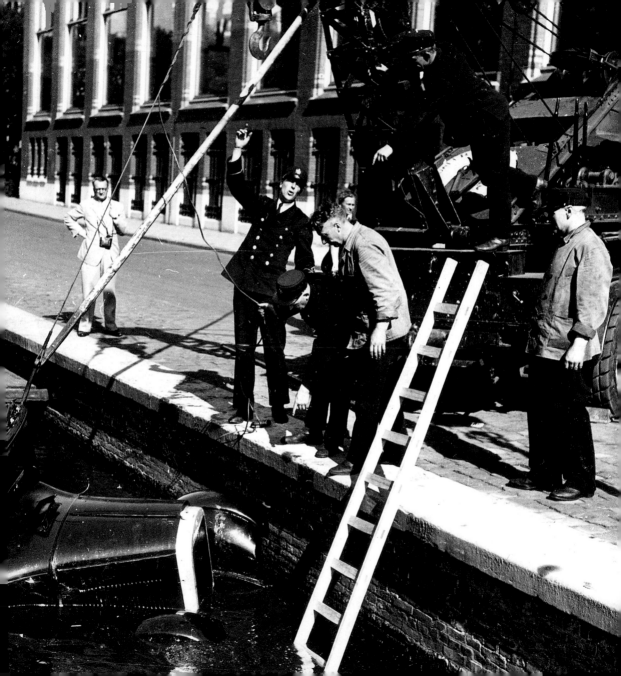

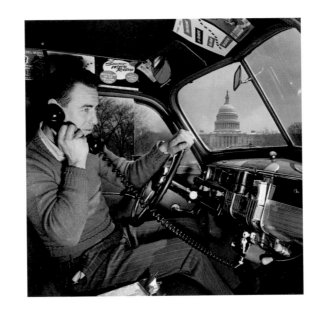

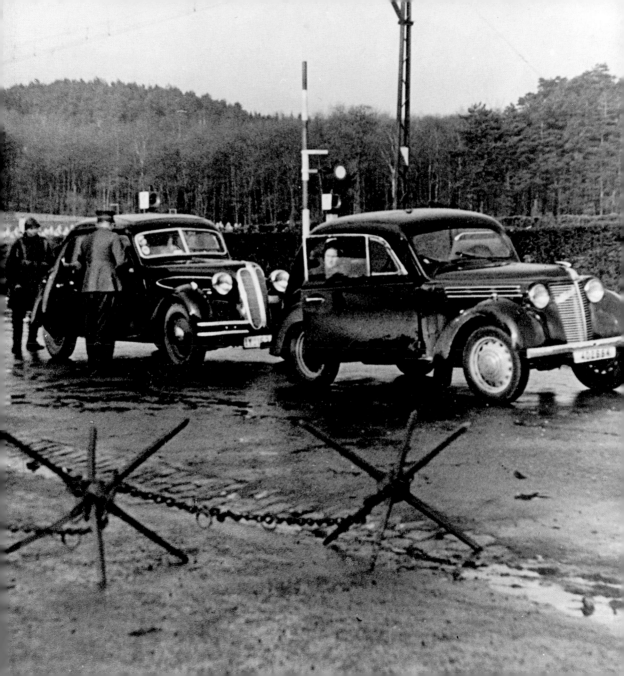

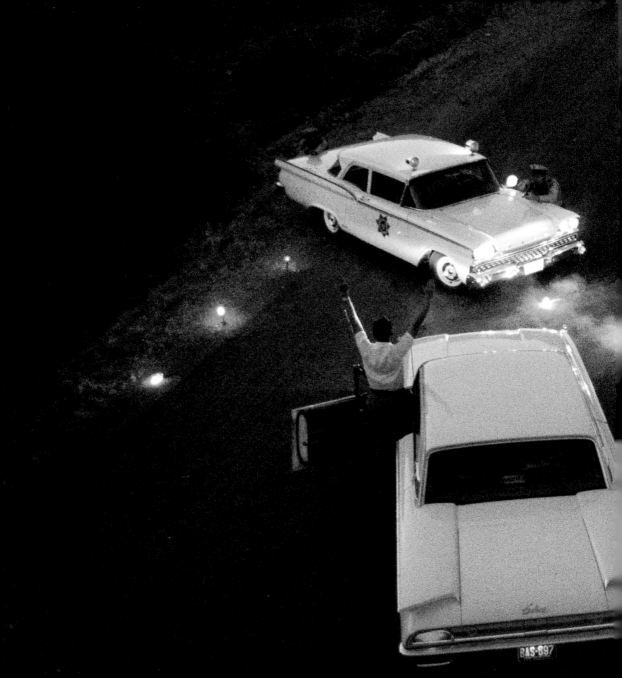

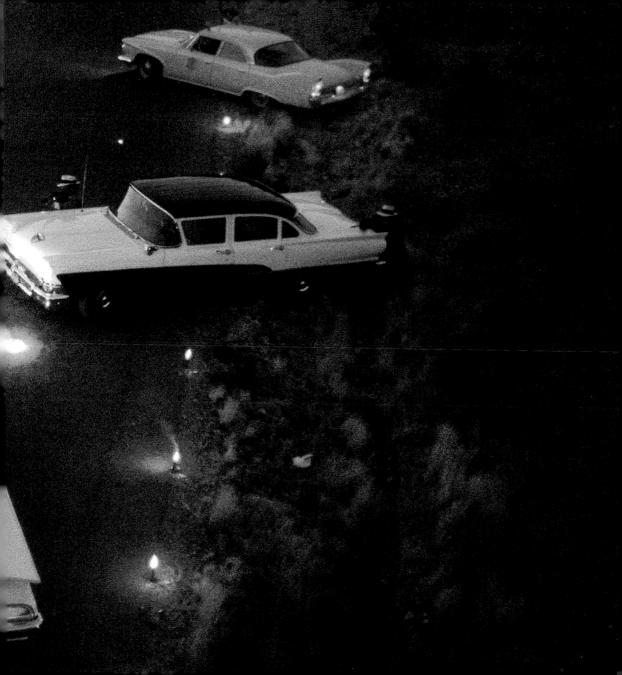

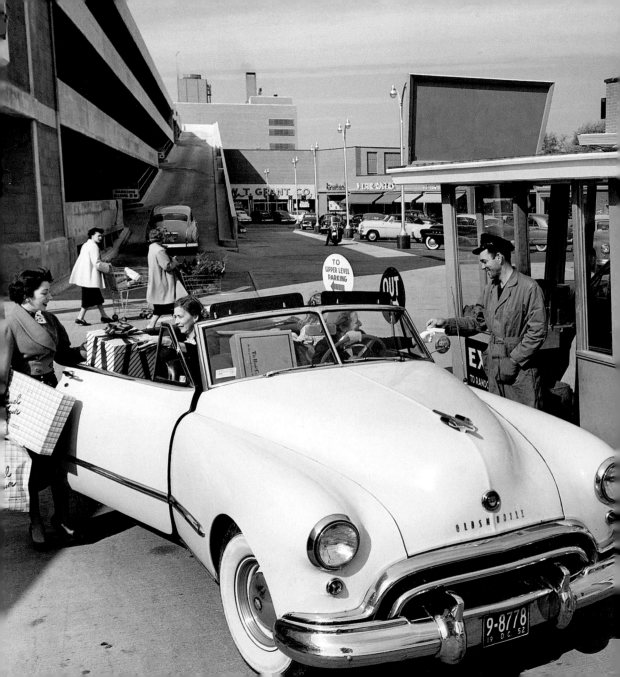

ARLINGTON, VIRGINIA
1953
DAVID BOYER

preceding pages
MARICOPA COUNTY, ARIZONA
1961
ROBERT SISSON

following pages
CHICAGO, ILLINOIS
1931
CLIFTON ADAMS

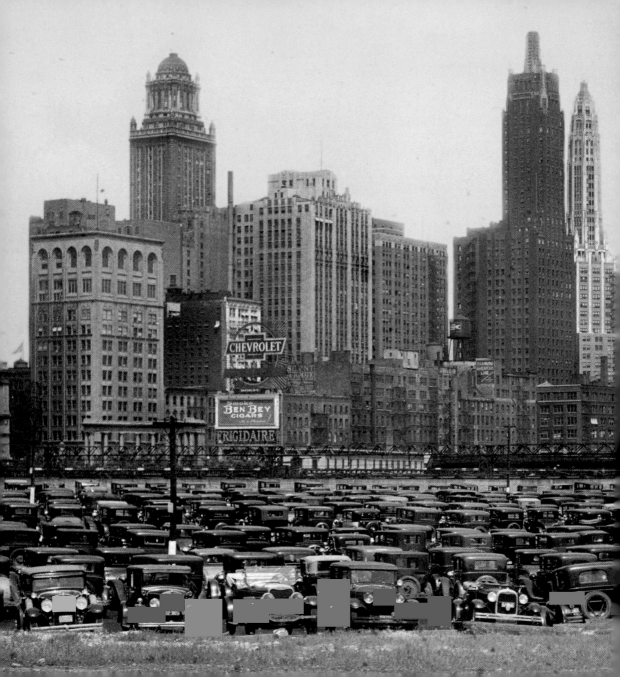

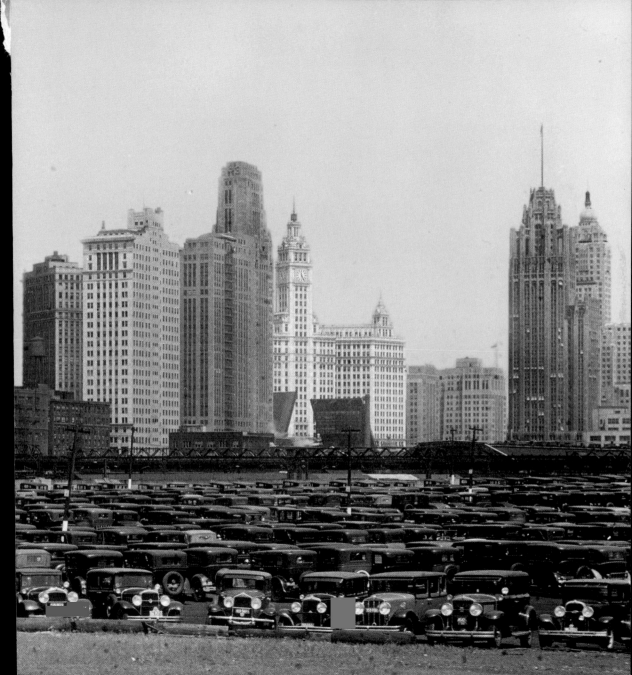

Jumping in the car and getting

away has been a fixture in our imaginations for nearly a hundred years. But it turns out that the car itself is a place to be, with its own atmosphere of calm or adventure, solitude or friendship. A quiet conversation on a road trip, an evening in a drive-in movie, an exotic safari—all are memorably experienced from inside cars. Young couples learned about intimacy in the backseats of cars in the fifties and sixties. Geographic photographers—usually not setting out to photograph any of this—have encountered it and found it irresistible.

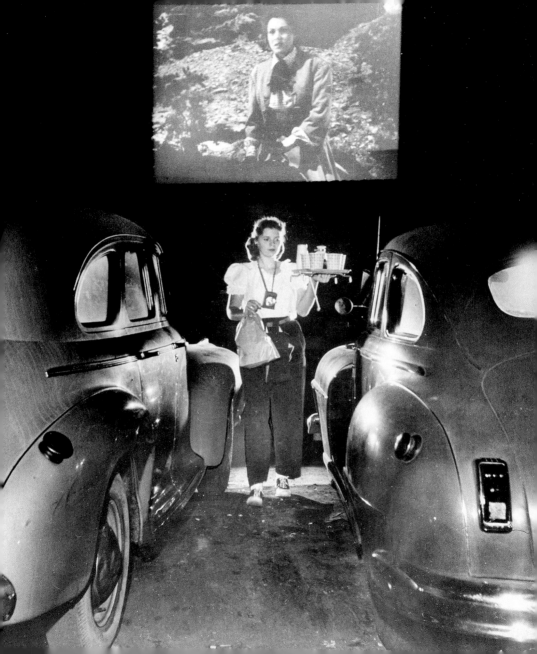

CAMDEN, NEW JERSEY
1933
TIME-LIFE PICTURE AGENCY

preceding pages
ALBUQUERQUE, NEW MEXICO
1987
JODI COBB

MONTANA
1984
SAM ABELL

following pages
LIMA, PERU
1995
WILLIAM ALBERT ALLARD

AFGHANISTAN
2002
LOIS RAIMONDO/
THE WASHINGTON POST

MONTEVIDEO, URUGUAY
1930
URUGUAY DEPARTMENT
OF PUBLICITY

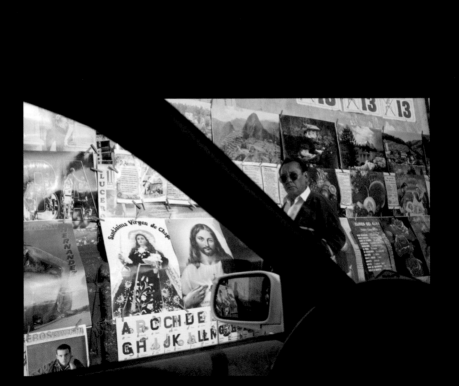

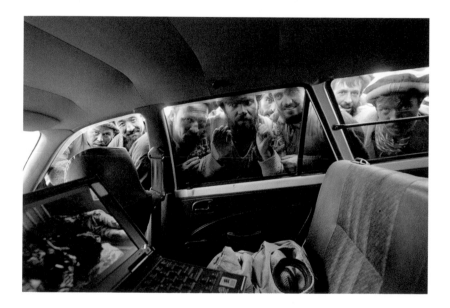

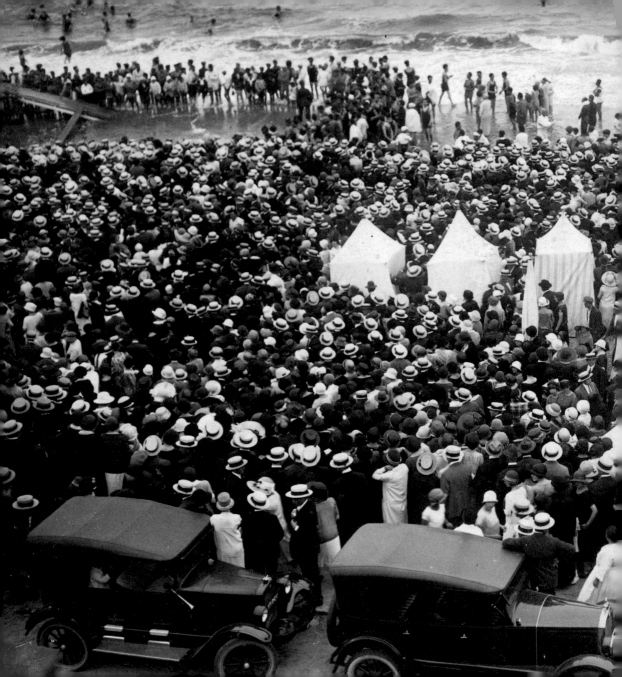

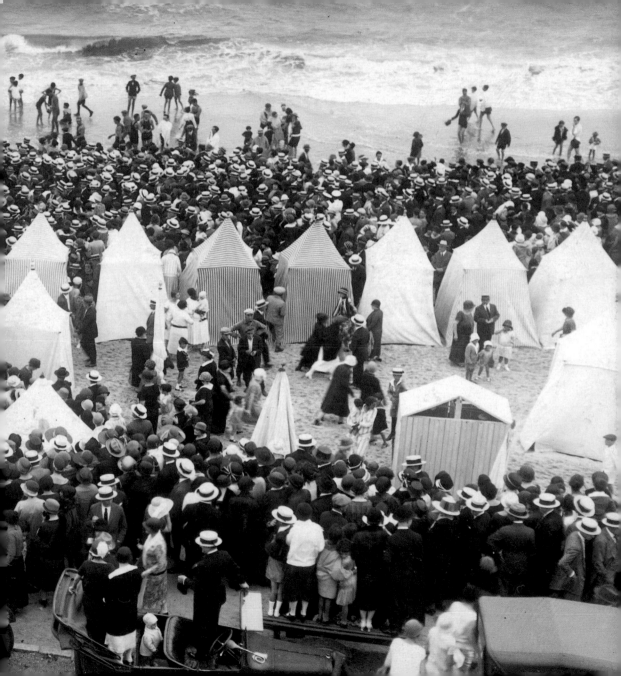

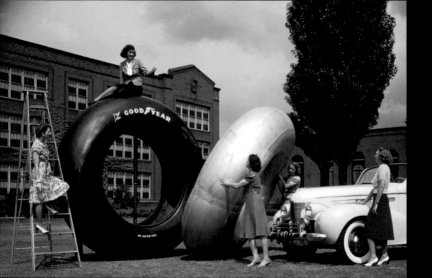

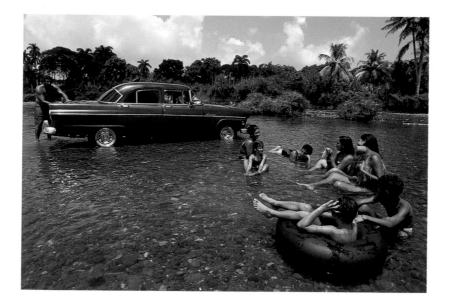

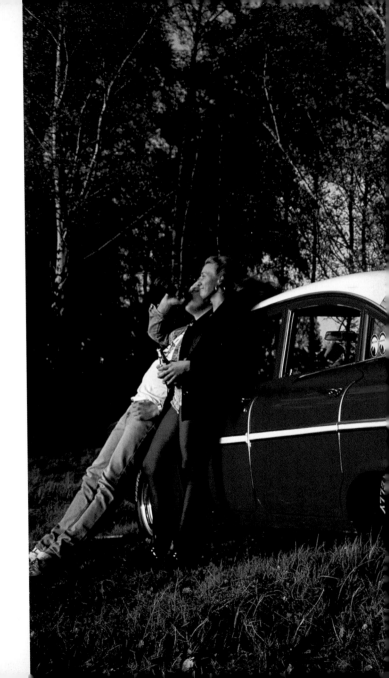

HASSLEHOLM, SWEDEN
1993
TOMASZ TOMASZEWSKI

preceding pages
USA
1940
WILLARD R. CULVER

CUBA
2001
CRISTOBAL CORRAL

HARTSBURG, MISSOURI
1973
H. EDWARD KIM

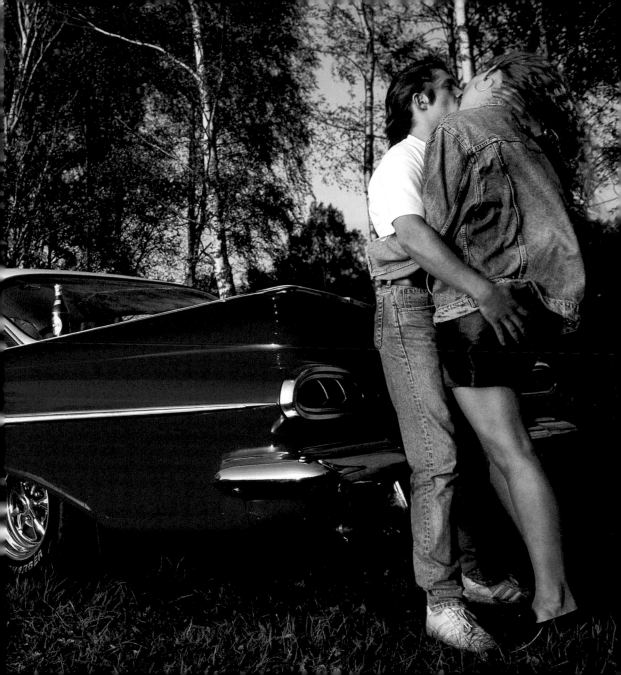

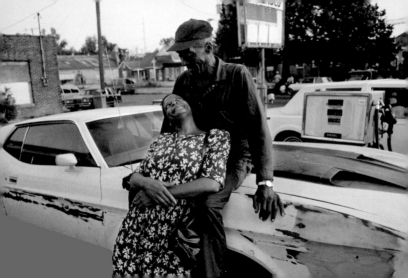

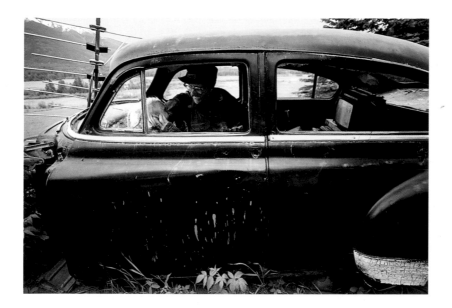

WHITE SANDS NATIONAL
MONUMENT, NEW MEXICO
1957
WILLIAM BELKNAP

preceding pages
GREENVILLE, MISSISSIPPI
1998
WILLIAM ALBERT ALLARD

DUNSTER, BRITISH
COLUMBIA
1986
CHRIS JOHNS

following pages
ALGONQUIN PARK
1932
PHOTOGRAPHER UNKNOWN

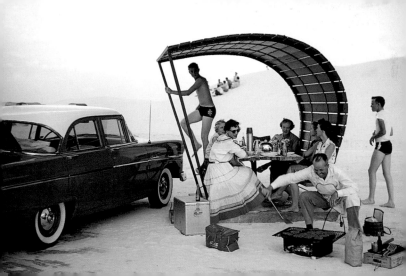

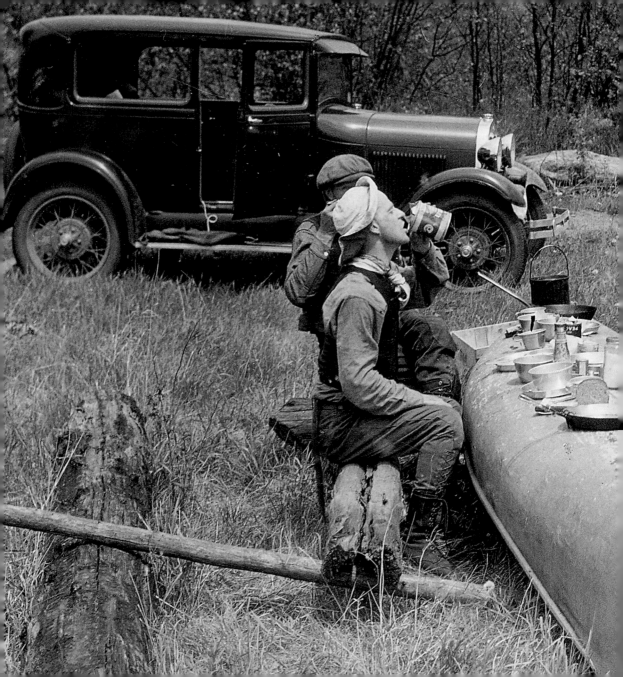

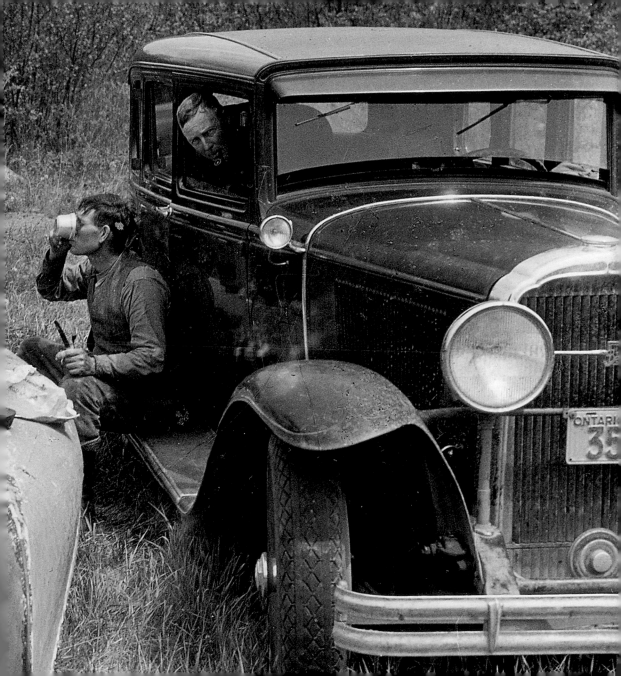

USA
1923
DENVER TOURIST BUREAU

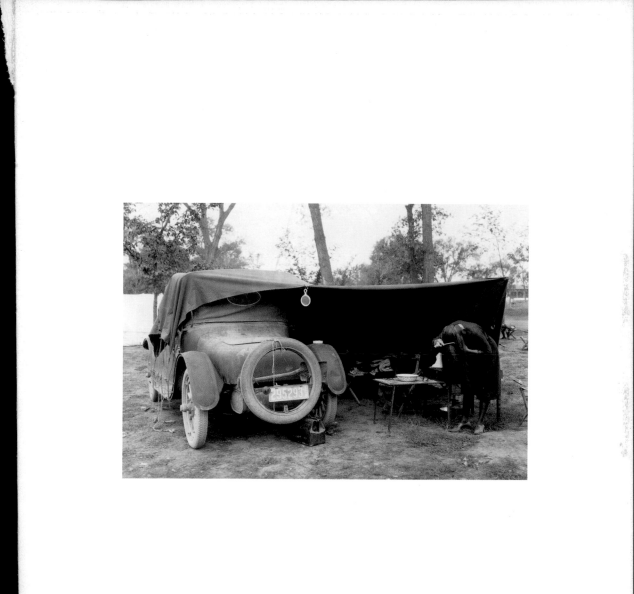

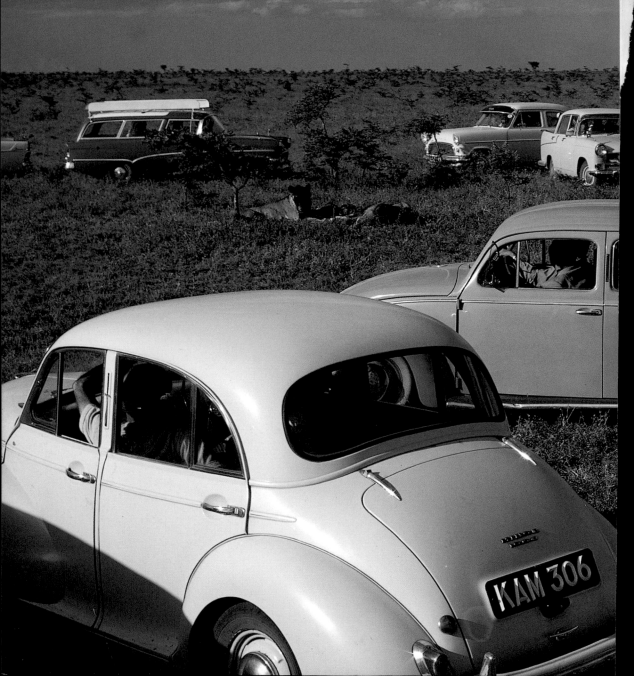

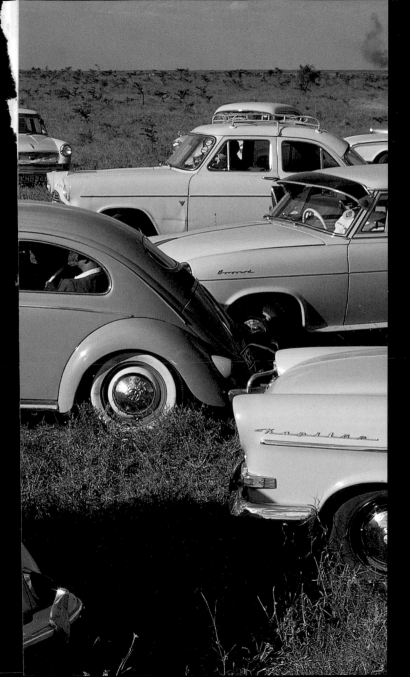

NAIROBI ROYAL NATIONAL
PARK, KENYA
1962
VOLKMAR WENTZEL

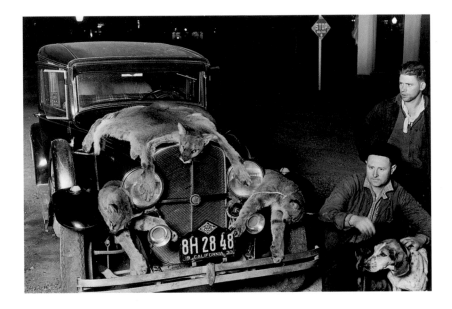

CALIFORNIA
1935
REDWOOD EMPIRE
ASSOCIATION

following pages
SAN JOAQUIN VALLEY
1942
B. ANTHONY STEWART

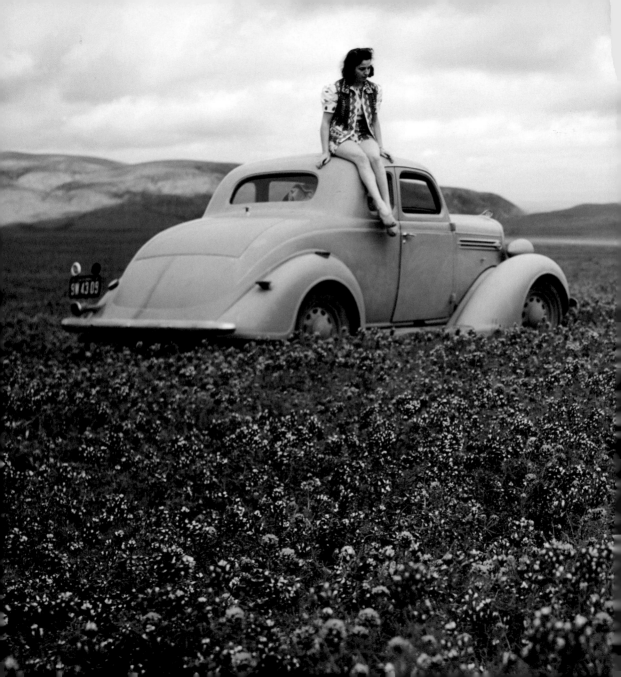

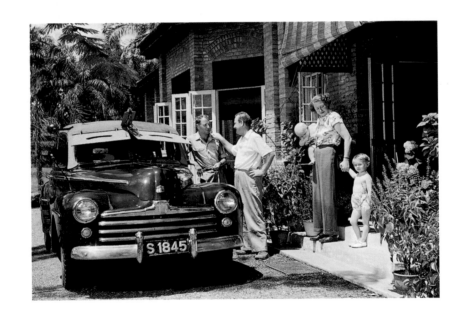

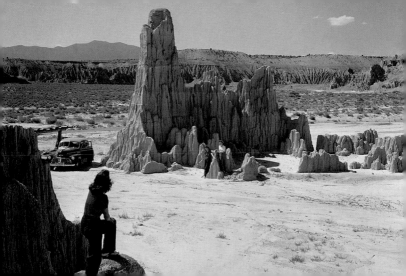

CALIFORNIA
1949
INTERNATIONAL NEWS PHOTOS

preceding pages
KUALA LUMPUR, MALAYSIA
1953
J. BAYLOR ROBERTS

CATHEDRAL GORGE, NEVADA
1946
W. ROBERT MOORE

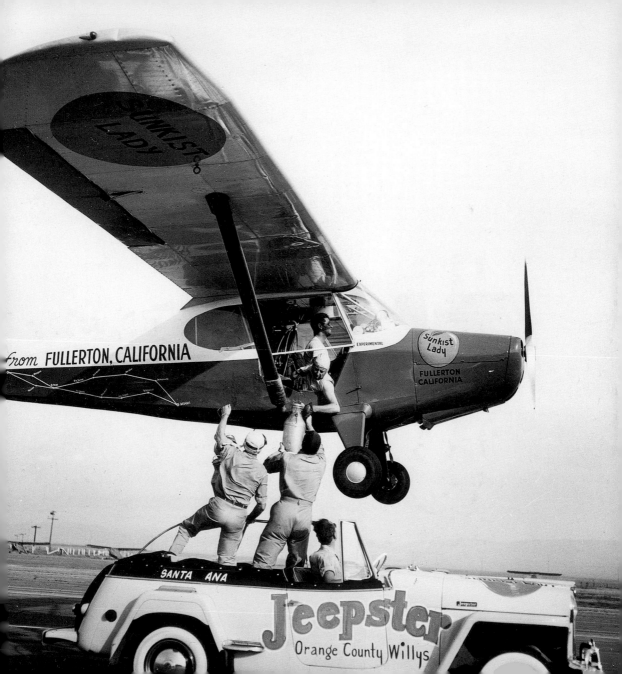

WASHINGTON, D.C.
2002
LANDON NORDEMAN

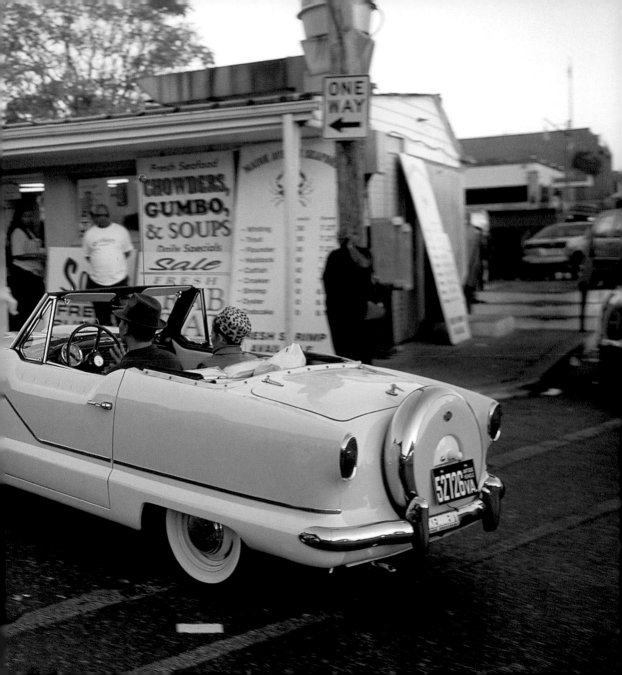

CALIFORNIA
1954
J. BAYLOR ROBERTS

following pages
PHELPS COUNTY, NEBRASKA
1998
JOEL SARTORE

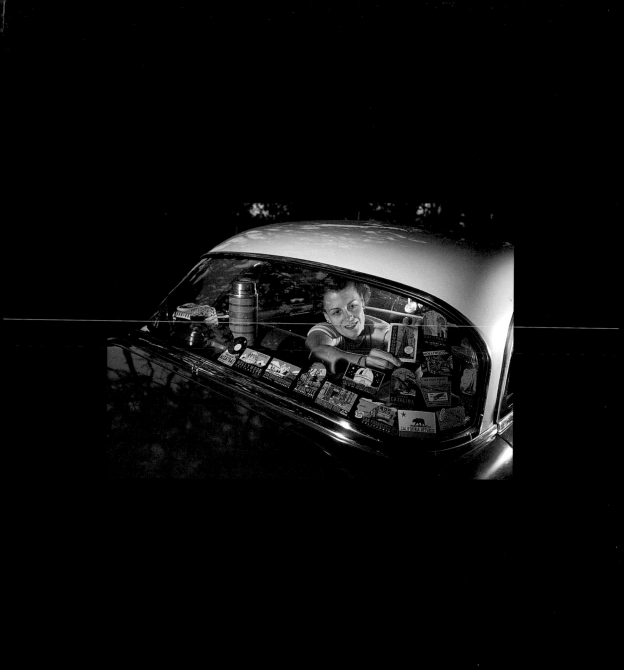

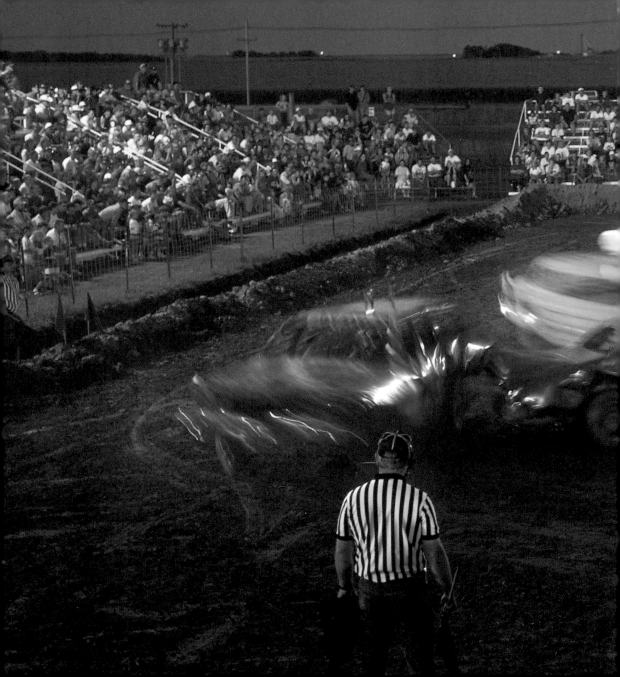

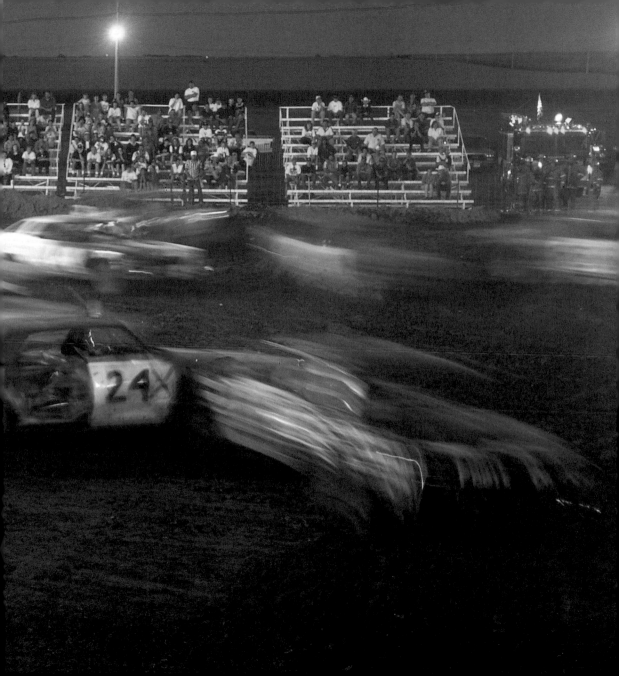

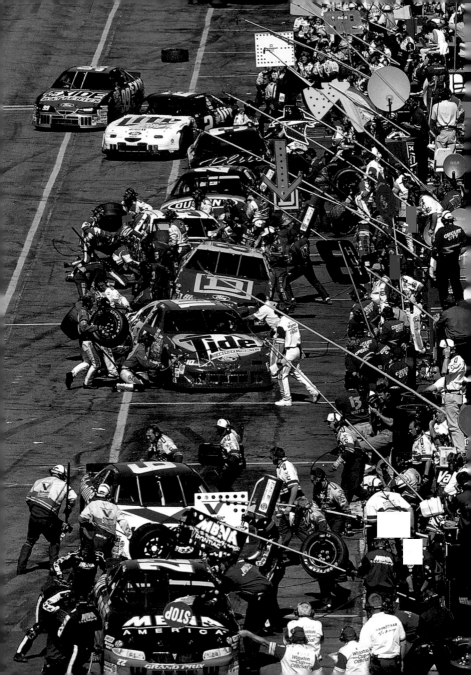

MARTINSVILLE, VIRGINIA
1998
JOSEPH S. STANCAMPIANO

following pages
ATHENS, GEORGIA
1986
SAM ABELL

LONDON, ENGLAND
1935
TOPICAL PRESS AGENCY

ENGLAND
1966
GEORGE MOBLEY

NORFOLK, VIRGINIA
1951
DOUGLAS MACARTHUR
MEMORIAL

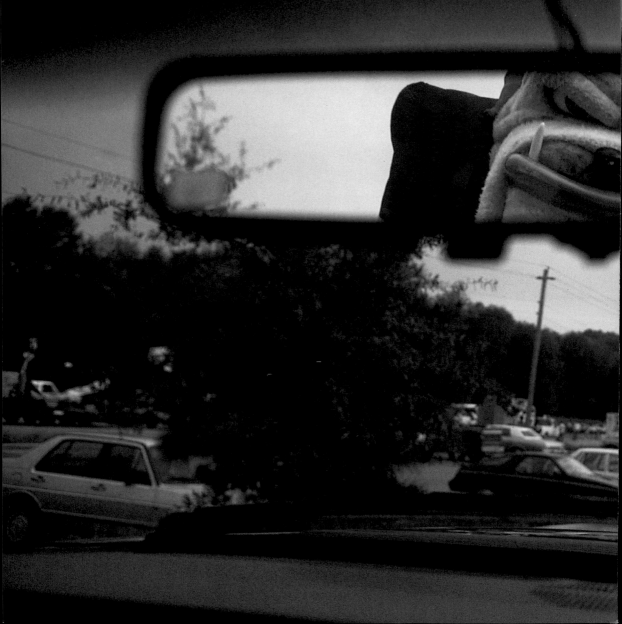

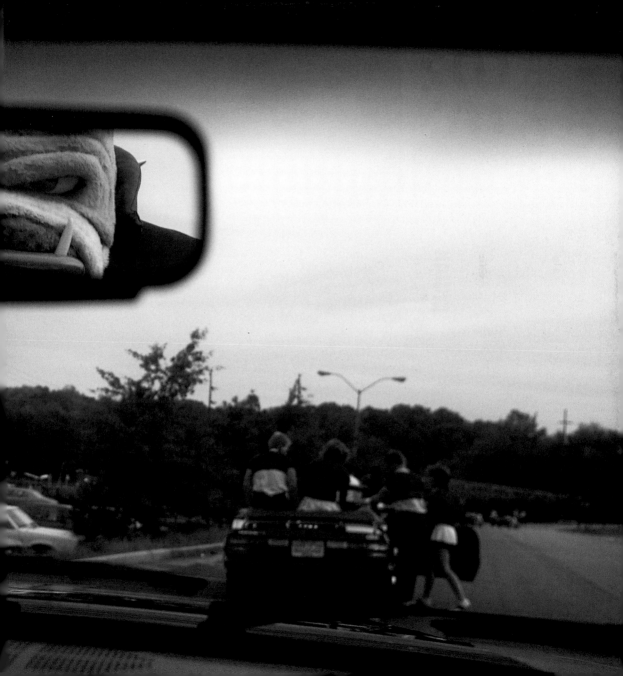

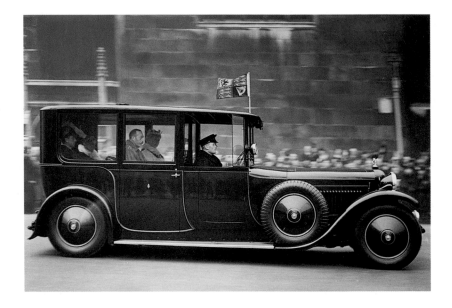

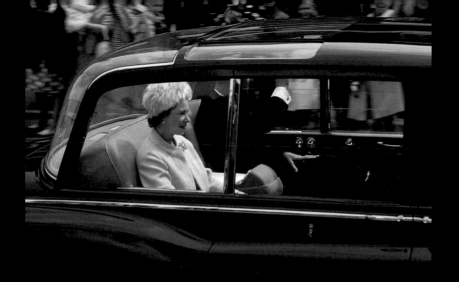

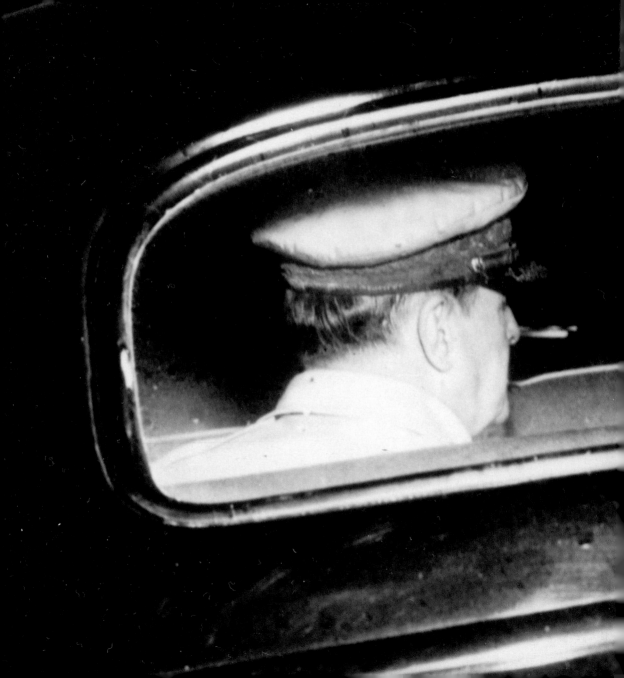

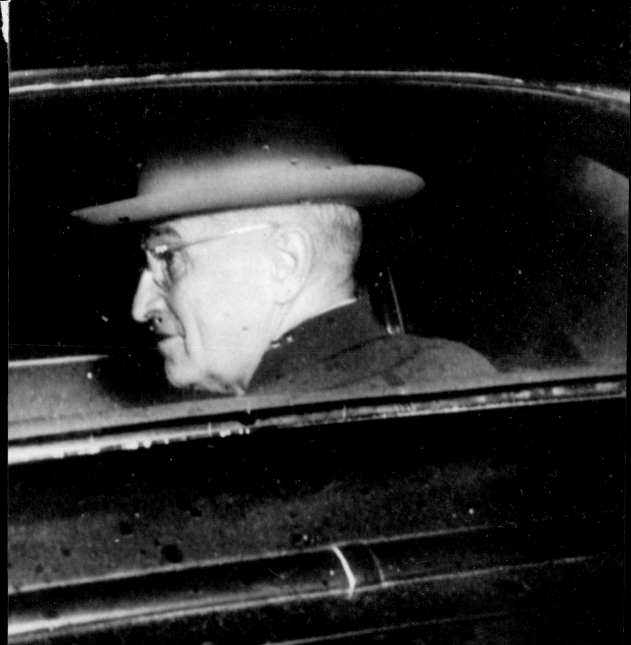

It would be possible to publish

an entire book of photographs of car wrecks strewn around the globe, in vacant lots and backyards, on roadsides and in dumps. Many photographs of them are beautiful—pictures that are graphically strong and speak to us of lives the cars once held. The old cars seem alive themselves sometimes, creatures that have seen much and ended up in a whimsical final resting place.

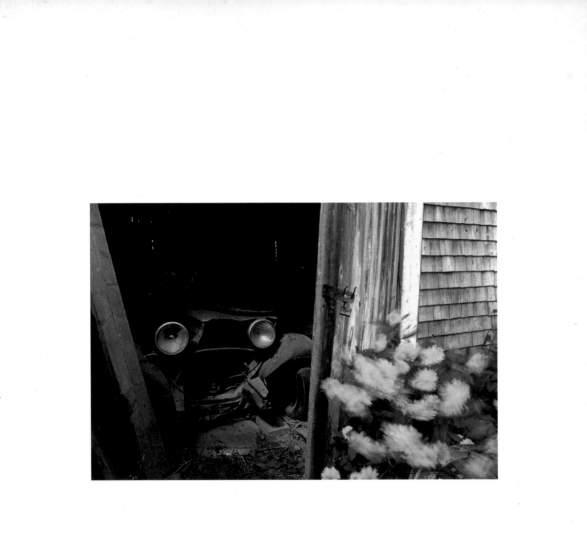

MAINE
1984
BRUCE DALE

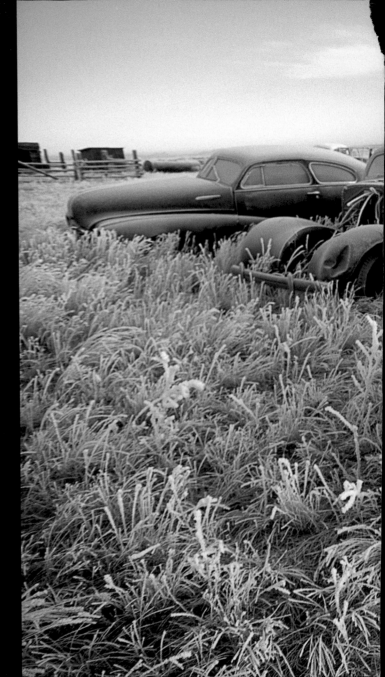

WYOMING
1992
RICHARD OLSENIUS

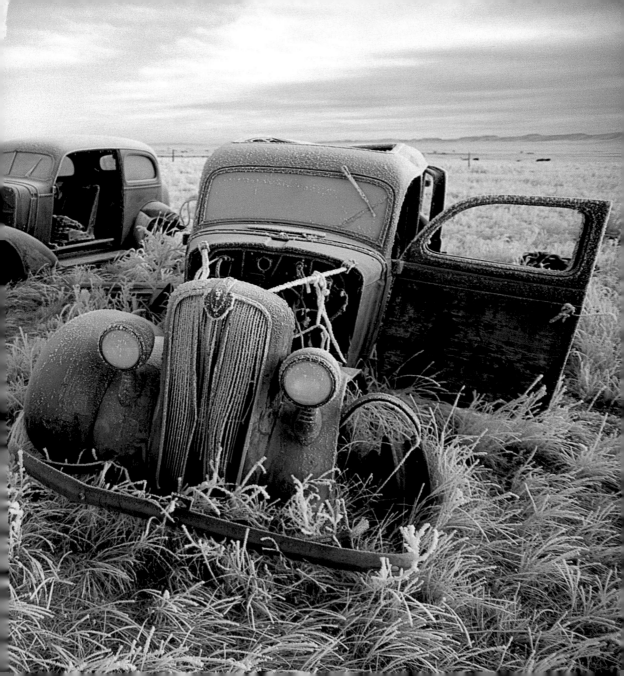

USA
1978
BRUCE DALE

following pages
CARHENGE, ALLIANCE,
NEBRASKA
2000
TOMASZ TOMASZEWSKI

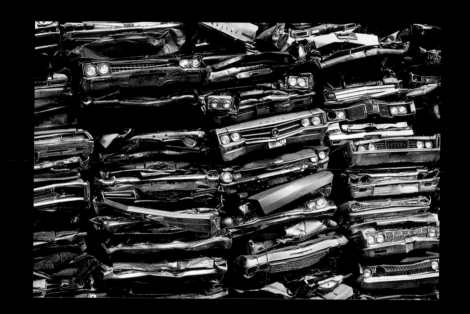

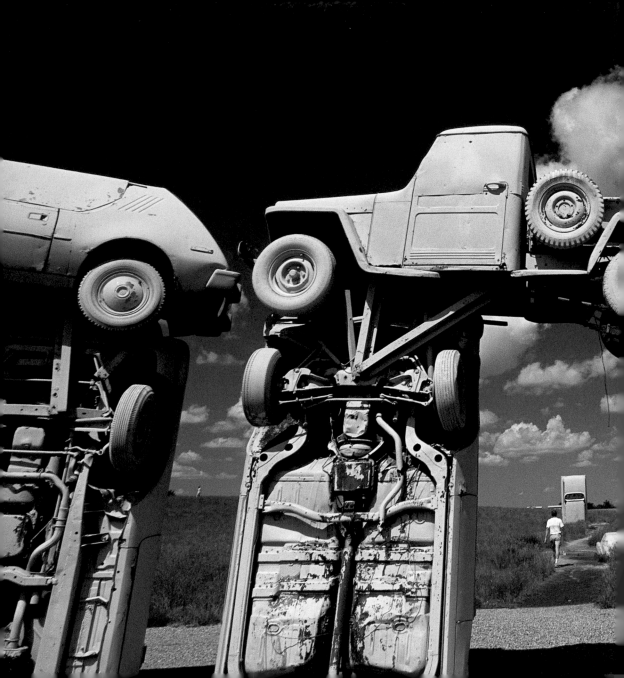

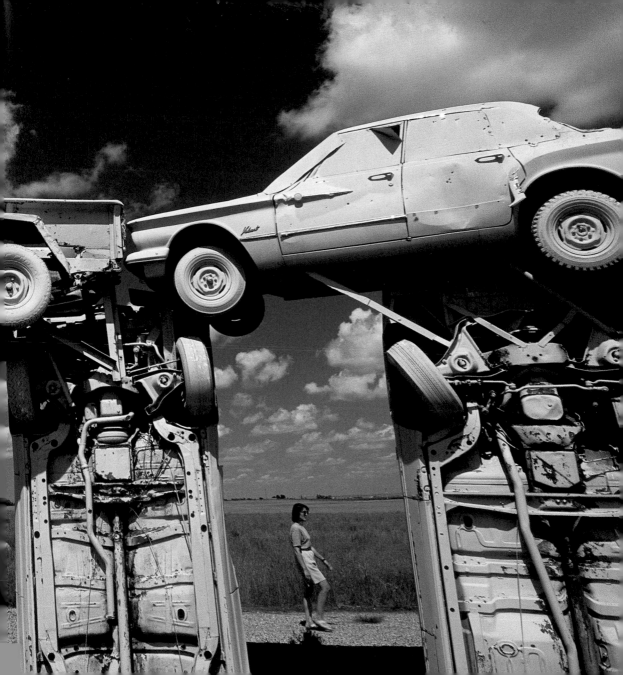

Cars
by Leah Bendavid-Val

Published by the National Geographic Society
John M. Fahey, Jr., *President and Chief Executive Officer*
Gilbert M. Grosvenor, *Chairman of the Board*
Nina D. Hoffman, *Executive Vice President*

Prepared by the Book Division
Kevin Mulroy, *Vice President and Editor-in-Chief*
Marianne R. Koszorus*, Design Director*
Leah Bendavid-Val, *Editorial Director, Insight Books*

Staff for this Book
Leah Bendavid-Val, *Editor*
Rebecca Lescaze, *Text Editor*
Marianne R. Koszorus, *Art Director*
Vickie Donovan, *Illustrations Editor*
Joyce M. Caldwell, *Text Researcher*
R. Gary Colbert, *Production Director*
John T. Dunn, *Technical Director, Manufacturing*
Richard S. Wain, *Production Project Manager*
Sharon C. Berry, *Illustrations Assistant*
Natasha Scripture, *Editorial Assistant*

We would like to give special thanks to Susan E. Riggs, Bill Bonner, and Patrick Sweigart for their hard work and generous support for this project.

Library of Congress Cataloging-in-Publication Data available upon request
ISBN 0-7922-6169-0

One of the world's largest nonprofit scientific and educational organizations, the National Geographic Society was founded in 1888 "for the increase and diffusion of geographic knowledge." Fulfilling this mission, the Society educates and inspires millions every day through its magazines, books, television programs, videos, maps and atlases, research grants, the National Geographic Bee, teacher workshops, and innovative classroom materials. The Society is supported through membership dues, charitable gifts, and income from the sale of its educational products. This support is vital to National Geographic's mission to increase global understanding and promote conservation of our planet through exploration, research, and education.

For more information,
please call 1-800-NGS LINE (647-5463)

or write to the following address:

1145 17th Street N.W.Washington, D.C. 20036-4688
U.S.A.

Visit the Society's Web site
at www.nationalgeographic.com.

Front cover and page 3: Pasadena, California/1997/ Michael Nichols

Additional Credits: p. 42 and Back Jacket, Ewing Galloway; p. 49, Ewing Galloway; p. 106, Getty Images; pp. 124-5, Canada Department of Lands & Forests; p. 137, CORBIS; p. 148, Hilton I Archive by Getty Images.